# PREHISTORIC ART

## Paleolithic Painting and Sculpture

P.M. GRAND

STUDIO VISTA

## CHRONOLOGICAL CHART
## OF PREHISTORIC CULTURES

| Date B. C. | Period or Culture | Era |
|---|---|---|
| 5,000 | | Neolithic |
| 10,000 | Azilian | |
| | Magdalenian VI | |
| | V | |
| | IV | |
| | III | |
| | II | |
| 15,000 | I | |
| | Solutrean | |
| 20,000 | | Upper Paleolithic |
| | Gravettian | |
| 25,000 | | |
| | Aurignacian | |
| 30,000 | | |
| 35,000 | Chatelperronian | |
| | Mousterian | |

Approximate dates of prehistoric cultures as determined by radiocarbon testing. (After Leroi-Gourhan).

© 1967 il Parnaso Editore
Published in London by Studio Vista Ltd,
Blue Star House, Highgate Hill, London, N 19
SBN 289 27712 4
*Printed in Italy*

# Table of Contents

# List of Illustrations

# INTRODUCTION

1

Like the "corrida," the running of the bulls, the spectacle of prehistoric art leaves us with the disturbing sense of an encounter, fugitive and intense, with another world. It is a feeling no one can escape. The hoary wild herd is strangely familiar to us: red bison, great black bulls, rows of little horses, long-haired mammoths, there for over ten thousand years, lost in the night of the now famous caves of Altamira and Lascaux, like a message "from the bottom of the ages." The discovery of prehistoric art has been pursued at a steady pace since the beginning of the century. Today, when the humblest survey devoted to works of art of the past cannot do otherwise than reproduce these works in its opening page, this art risks becoming just one more episode within the singularly enlarged "imaginary museum" of the human race. The time has come to place prehistoric art and to define it, discounting naïve enthusiasms and recognizing clearly the limitations of our knowledge and interpretation.

In the twentieth century the curiosity of the Western world for arts other than its own has become so avid that no culture, present or past, could hope to escape it. The concept "work of art" has undergone a kind of mutation. We no longer restrict the privilege of beauty to classic styles, but accept and even prefer Luristan bronzes, Peruvian pottery, Australian bark paintings. In a world that no longer recognizes "barbarians," artistic creation is profoundly modified by the invasion of an infinitely varied supply of data. Our culture sifts an incessantly multiplying repertory of known, unknown and mis-known "masterpieces" and "treasures," disseminated by innumerable exhibitions and encyclopedic compilations. In the universal upheaval, the promotions of fashion are directed to the archaic and the primitive. The products of "primitive mentality" appeal to a sensitivity which is easily fatigued, it turns out, by the Greeks, the Romans, the Renaissance and Gothic cathedrals. The taste for the foreign, the craving for new horizons and exoticism, has degenerated into faddishness. The sudden appetite of the general public for Aztec sculpture or the masks of the New Hebrides follows, closely or from a distance, the lead of an avant-garde that, committed to a "universe of forms," lays claim to all visual experience, whatever its nature or origin.

Prehistoric art began to be known by the specialists just as the popular aesthetic climate was being formed that was

2

3

4

5

*1  Raymonden (Dordogne). Sketch by Breuil of perfo-rated staff showing designs on both sides. The tapered point may have served as a dagger: it bears traces of use. The decoration comprises notches, a reindeer's head, fishtails, barbed signs. (Compare with the de-signs on p. 33). Possible traces of thongs at the edge of the orifice may indicate that it was used as a sling hole.*

*2  Les Trois-Frères (Ariège). Little masks found scatter-ed in a complex of engravings. They seem introduced surreptitiously in the medley of animal representations in which they occur. Some have the ghostly air also noticeable in figures at Le Portel, Lascaux, Font-de-Gaume, and Les Combarelles.*

*3-4  Finger tracings. At Altamira (Santander), a bovid's head well rendered by a sensitive arabesque. At Pech-Merle (Lot), a leaning female silhouette.*

*5  Pair-non-Pair (Gironde). A little engraved mask, of the "ghost" type, is placed where the animal's ear would normally be.*

① PÉRIGORD
CHARENTE

② CANTABRIAN
MOUNTAINS

③ PYRENEES
BASQUE
COUNTRY

④ LANGUEDOC
RHONE

⑤ EASTERN
⑥ SPAIN

⑦ SOUTHERN
ITALY

⑧ SOUTHERN
SPAIN

*6 Centers of prehistoric rock painting in western Europe.*

to "discover" it. Well documented by the middle of the century, it arrived at the right moment to meet the preferences and tastes of the times. The consequent popularized appeal of the works has led to certain problems — first among them the practical considerations involved in the physical preservation of works at once precious, fragile and irreplaceable.

Such considerations have rightly led to the closing of the cave of Lascaux, which had become by the summers of 1961 and 1962 a major tourist attraction. Two thousand or more persons of all ages and nationalities daily joined the long lines in front of the cave. Thanks to the publicity of the Spanish tourist office, Altamira was also visited in droves by sightseers. And yet, several masterpieces, and these of the first rank, had been recognized considerably earlier without causing this kind of excitement. Few tourists find their way to such sites near Lascaux, admittedly less spectacular, as La Mouthe, Font-de-Gaume, or Les Combarelles; few have seen the "Salon Noir" of Niaux, which is generally deserted in spite of its impressiveness, or the masterpieces of "art mobilier" in the museum of Saint-Germain-en-Laye. It would be disgraceful if, for the sake of an often childish satisfaction justified by no serious interest, the worn pigments miraculously saved through millennia were exposed without discrimination to the consequences of the comings and goings of the crowds.

Without denying the obvious fascination of the mural paintings, we must realize the inappropriateness of making a show of them. The art of the Age of the Reindeer was not addressed to our entertainment. Through a series of geological accidents, we have come to know certain of its manifestations; but our inquiry into works which, in the civilizations which conceived them, very probably had a rather secret character, must proceed with respect and restraint.

On quite another level, another kind of restraint becomes essential. The time has come humbly to admit that what we call "prehistoric art" is only an assemblage of relics. They are numerous to be sure — about a hundred painted caves, thousands of decorated objects, some sculpture — but of their numerical relation to the total production we are grossly ignorant. We are equally ignorant of their true significance to the civilizations which produced them.

It is true that in dealing with other cultures also we come upon gaps and blank areas in the balance sheet of artistic achievement as revealed by excavated objects or the monuments which have survived. But when these civilizations do not speak to us through their own writings or through the texts of others in history's increasingly tightened web of cross-confirmations, some play of transmission generally still reveals something of their weight and contour. Parallel to the knowledge conveyed by physical vestiges of dwellings, temples, adornments and tombs, we have for ancient societies a kind of composite profile which gives us clues to their life course. This picture, brilliantly illuminated for the classical civilizations, which were themselves eager to provide a detailed commentary on their own destiny, becomes more hazy as one goes back in time. For the era just before the dawn of the early civilizations we have some vague sense of itineraries of migrations and sites chosen by migrant tribes, but of the truly prehistoric period, nothing of the kind seems to subsist in the memory of men. Its remains come to us naked and dumb, like the dispersed fragments of a forgotten skeleton.

Merely because these remains include many works of art, let us not hastily try to deduce the living complex from which they originated. We must beware of asking prehistoric art to reveal prehistory to us. It is impossible to make the painting of the Upper Paleolithic speak the language of the Upper Sepik and of the American Plains Indian. How could one hope to find analogies for the structure and aims of a society where nothing of the society as such remains? Those who have had the illusion of seeing "sorcerers" and "rites" live again on cave walls have simply, with more romanticism than sound reason, bestowed a primitive mentality conceived after recent examples on populations whose gods and whose laws will remain forever unknown to them. The glamour of the sacred is particularly strong in our epoch, which has almost lost sight of the sources of the supernatural. Not to be deceived by this glamour is a major requirement in any investigation of cultures that present to us vastly more questions than answers.

After some one hundred years, we have arrived at a few reliable conclusions about prehistory. Today, entering an objective phase, prehistorians have sufficient humility to approach the dangerous realms of interpretation with the greatest systematic precautions. The temptation to furnish would-be explanations of works of art is particularly strong, but we must call to mind the very peculiar position of the works with which we are concerned.

First art of humanity, it is often said. Probably. At any rate, for us the most ancient art of which we have any cognizance. As such, prehistoric art occupies an exceptional place in our vast art holdings. The position of primacy implies a significant limitation. Here we have an art forcing us to relinquish the customary references to antecedents and influences that would be so very helpful for an understanding of its mainsprings. And yet this art does not offer us the compensation of revealing to us the first movement of an absolute continuity. One cannot treat the ibexes of Cougnac as though they were elementary attempts by beginners, followed in a progressive sequence, without regression, by Michelangelo, Poussin, Cézanne, Picasso. These figures drawn in yellow ocher are already paintings

7 *Altamira (Santander). Bison from the black series preceding the great ceiling. The animal remains flat and schematic. Despite the absence of modeling, the attitude is quite spirited.*

8 *Altamira. Detail of the hind on the ceiling. Note how expressively the anxious animal is rendered.*

9 *Altamira. Boar on the ceiling.*

7

8

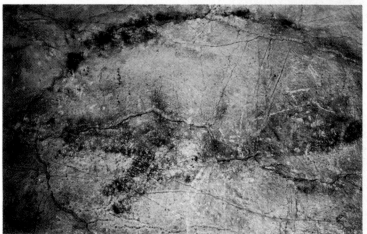

9

in their own right, as the horses of Le-Cap-Blanc and the Venus of Lespugue are, before the Greeks and Brancusi, sculptures in their own right. At the time of the first discoveries, an early stage in understanding is revealed by the statement: "This is the infancy of art but not an art of infancy." We know today that art has no infancy; that, depending on the period, it either exists or it does not.

This fully formed and adult art of the Upper Paleolithic gives us a unique sensation of happy surprise. "Nothing could have made one suspect in that very remote period, of which only some fragments were known, such an explosion of truly great and, of its kind, perfect art." (Abbé Breuil.) The art of Sumer does no more than particularize what could be expected from what we know of the Mesopotamian world, and the most recent pieces from Japan may betray an accent which we recognize to be imported from China — but prehistoric art, solitary and literally incomparable, has that touch of the marvelous which we may attribute to the character of unexpected revelation that attaches to it.

We have yet to define the boundaries of "prehistoric art" as it will be discussed in this book. Prehistoric art proper is generally taken as that of the Upper Paleolithic, also referred to as the Ice Age or, by its first historians, as the Age of the Reindeer. Although dating is uncertain, this period lasted roughly from 30,000 to 10,000 B.C. With its enigmatic and arresting mural works, of which only a few centers lie outside the core area known as the Franco-Cantabrian region (southwestern France and border of the Pyrenees, northwestern Spain), with its monumental sculpture, and with the brilliant achievements of its more widespread "art mobilier" (i.e. portable art, mostly carved objects and plaquettes found in various parts of western Europe and as far east as the Don), it constitutes that golden age to which the greater part of this book will devote itself. Later artistic traditions, some of which are still practiced or have only recently disappeared, will be touched on only marginally.

In a misleading way, the adjective "prehistoric" is used to describe various productions that have little in common beyond the fact of not belonging to the great civilizations that have employed writing. It must be added that when these "prehistoric" productions are thus separated from the time scheme of history, they are sometimes difficult to distinguish from "primitive" ones. The ambiguousness of

*10  Altamira (Santander). Superb red and black bison on the ceiling. While some of the other bison—there are about fifteen altogether—are shown in a huddled posture (see Fig. 25) so as to adapt to the protuberances of the rock, this one presents an entirely classical prehistoric profile. Startled, the powerful beast is ready to attack, though it does not yet charge: it advances. The mass of the forequarters drops low, and the slender horns and legs give a precise note to the modeling.*

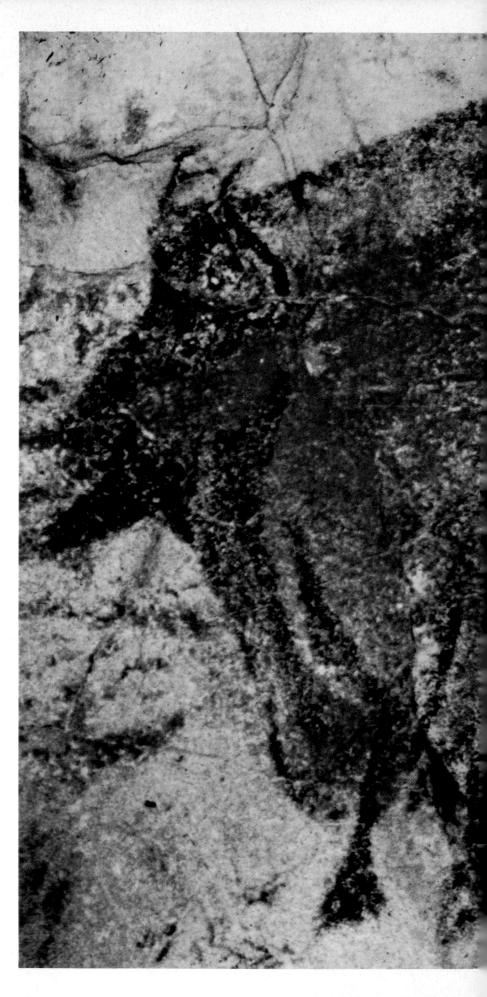

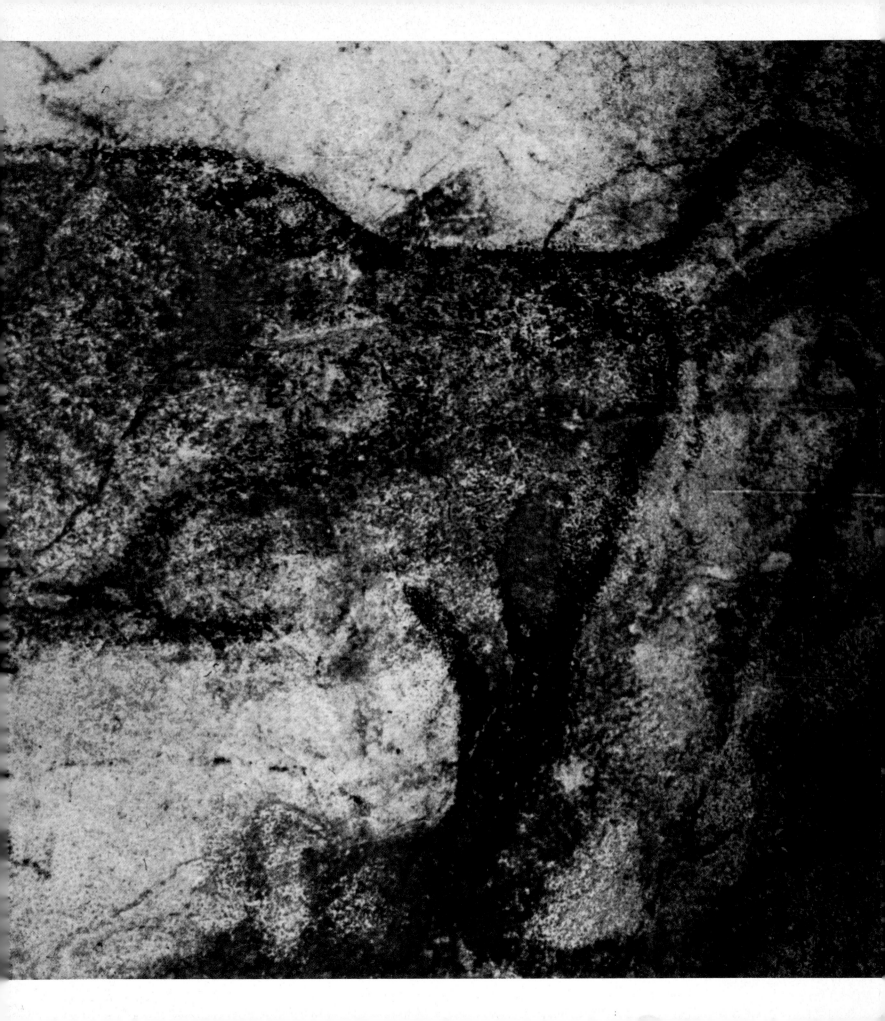

the word "prehistoric" is at the bottom of a strange confusion of terms. Strictly speaking, prehistory may be considered to be simply the span of man's existence before the end of the fourth millennium B.C., when the first historic civilization arose at Sumer. However, we currently say of the Tasmanians that they are "living prehistory," and in saying this we shift our meaning surreptitiously from the idea of a period in time to that of a state of being. This state is understood to be that of peoples whose tools antedate the use of metal. It is understood that this pre-historic condition can vary in length depending upon whether one is dealing with Eskimos or Aruntas or Mediter-raneans, and that it refers to a stage of civilization charac-terized by its tools — a stage that the classical prehistorians called the Stone Age. The discipline that studies this period

---

*11   Lascaux (Dordogne). Some figures from the most spectacular ensemble in all of rock art.*

*(a)   Axial Gallery. Large bull superposed on an earlier figure. The animal is clumsy in certain ways, with folds above the front legs, and stiff rear leg issuing from the belly; but the muzzle is very fine, remarkable for its soft, velvety, almost damp effect. The lower lip droops, the horns are lyre-shaped, and there are light areas around the eye and nostril.*

*(b)   Axial Gallery. Bister horse with a black mane, up-side down at the end of the gallery. Though both tra-cing and photographing present difficulties, they reveal a massive silhouette that invites comparison with the so-called "Chinese horses."*

*(c)   Axial Gallery. Leaping cow (5 ft. 7 in.). It has been suggested that the rear legs are raised to avoid the frieze of little horses underneath. The left rear leg is lifted to the flank.*

*(d)   Axial Gallery. Bister and black horse on the ceil-ing. Long hairs are prominent along the belly; the legs end in knobs. Note the light area on the inner side of the rear leg.*

*(e-f)   Great Hall of Bulls. Large bulls drawn with a broad stroke in fluid color. The monumentality of this group is due not only to the size of the figures (over 16 ft.) but also to the authority of the drawing.*

*(g)   Axial Gallery. The heads of the black cows are attractively grouped in this ceiling composition.*

*(h)   Axial Gallery. One of the so-called slender-limbed cows; another example is shown in Fig. 12.*

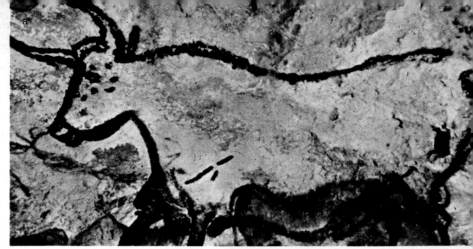

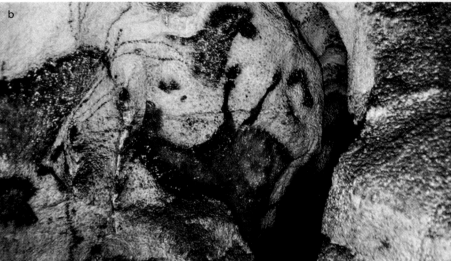

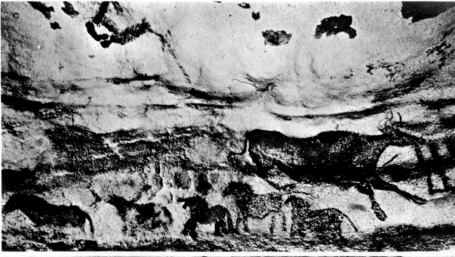

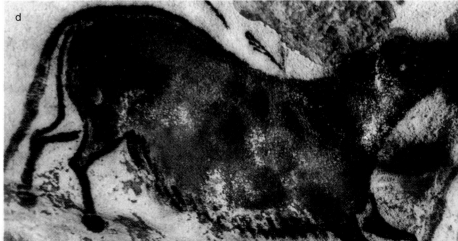

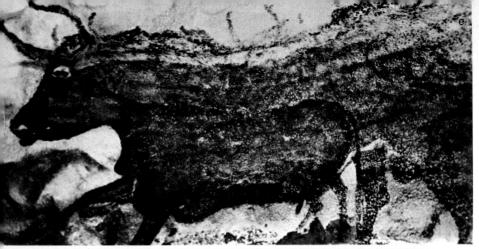

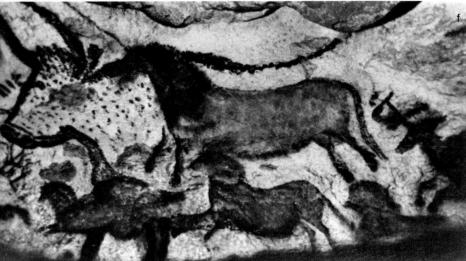

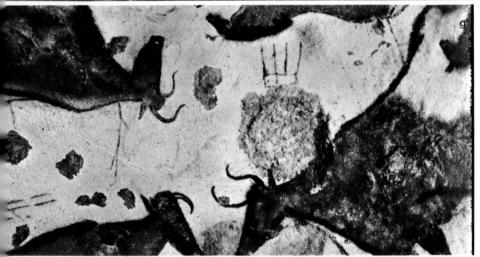

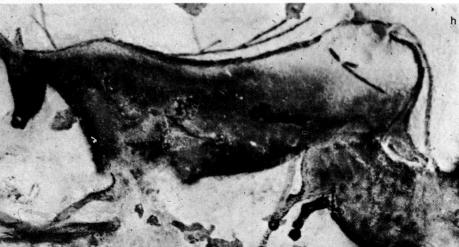

is likewise called "prehistory," rather inappropriately, since it does not concern itself with a period or a state of civilization, but is rather a specialization of archaeology. It would be more accurately described by the terms "paleo-archaeology" or "Frühgeschichte," which have been renounced by tradition.

The known works of prehistoric art are far from representing a uniform sampling from the entire prehistoric era. In the first place, as we have mentioned, the remains we possess are partial ones executed on materials not rapidly perishable, such as bone and stone, as against wood, hides and fibers. Our map of this art, moreover, corresponds merely to our finds rather than to the area actually covered. This map reflects climatic and geological conditions favorable to preservation — warm valleys with caves and shelters, thick sedimentary deposits. It depends at the same time on the existence of a curiosity and the means to satisfy it, and on chance.

Yet even recently, there has been a tendency to overestimate the artistic production of the immense spans of time outside history. To be sure, we are ignorant of the total of prehistoric works of art, but we do know of the voids that preceded this production. The lowest excavated layers of prehistoric sites yield no works of art, only implements lacking all aesthetic pretension. There has been much insistence on the paltry portion of the life of our species represented by historical times — one hundredth part; perhaps now one would have to speak of nearly two hundredth parts. But the development of Upper Paleolithic art must be separated from the endless preceding ages, together with history, in a final epoch: the adventure of *Homo sapiens*. In terms of absolute duration, this development has lately been considerably compressed. Some authors reduce Abbé Breuil's "four hundred centuries of cave art" to about one hundred centuries. We are dealing here with the counterpart of history, not with the whole dizzying stretch of man's existence on earth.

Prehistoric art, no longer losing itself in a mythical "night of the ages" will remain for us primarily a repertory of forms. The strictly pictorial aspects of this art are for the most part unaffected by the controversies roused by the brilliant current renewal of studies in France, following the death of Abbé Breuil. No attempt will be made in this book to arbitrate between the champions of intuition and of explanations based on hunting magic, on the one hand, and the champions of computer techniques and of explanations based on the duality of the complementary male and female principles, on the other. With only a brief description of the search for the sociological sources of the iconography, this text will concern itself with description of modes of expression and analysis of techniques and composition. The forms of prehistoric art must be considered first and foremost in their own right, as creations admirable not because they are prehistoric, but because they are works of art.

## PALEOLITHIC MURAL PAINTING:
## DISCOVERY AND INTERPRETATION

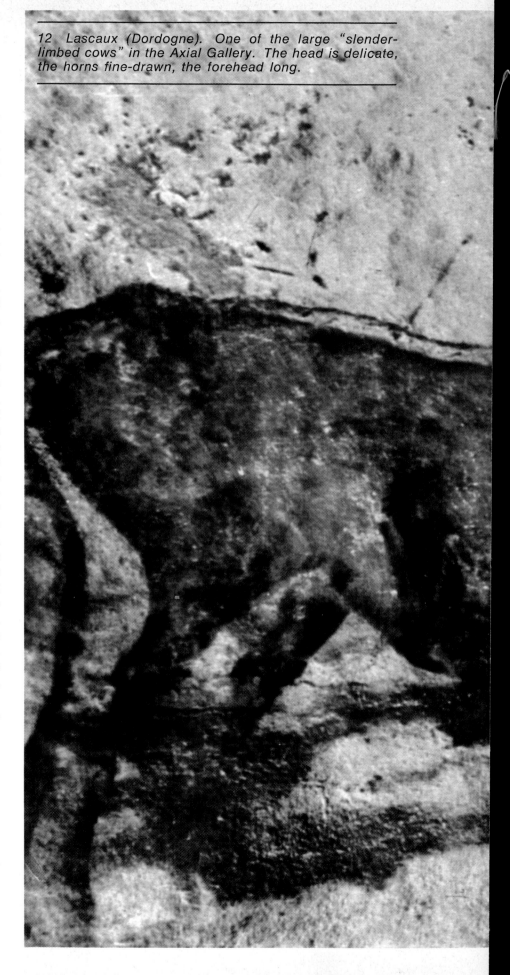

12 Lascaux (Dordogne). One of the large "slender-limbed cows" in the Axial Gallery. The head is delicate, the horns fine-drawn, the forehead long.

### The Exploration of the Caves

The paintings in the caves were curiously slow to be seen and recognized. Men tend to see what they wish to see and what they believe to be possible. Frenchmen had taken their Sunday walks through the cave of Niaux for years before, having become aware of what to look for, they discovered its marvels.

Before the new science of the nineteenth century began to reveal man's antiquity, there could, of course, have been no understanding of those paintings which were stumbled upon. During the controversy in 1956 over the authenticity of the painted walls at Rouffignac, a text dating from 1575 by one François de Belle-Forest was brought forward and cited as a proof that the murals in question were not of recent date. The book describes, rather confusedly and without distinguishing between art and nature, the "cluzeau," or cavern located near Miramont in Périgord, about which "great marvels" are told: "... inside there are fine halls and rooms, some paved in mosaic fashion with tiny stones in diversified colors, and one sees there some altars, and paintings in several places, and the traces of footprints of several kinds of animals large and small ..." The author's imagination associated this underground place and its representations with diabolic rites. He speaks of "the Venus idol," but he seems to have interpreted the markings on the walls as the kinds of scrawls ordinarily linked with commonplace erotic practices — "Love's larcenies" — rather than with religious rites. Yet some of his words seem to indicate that he has vaguely felt the impression of a sanctuary: "I think that this subterranean post is one where our idolatrous forefathers formerly went to sacrifice either to Venus or to the nether deities, the latter liking these cavernous places because of their resemblance to themselves, the former because Love's larcenies demand darkness; and I do not say this without cause, seeing that in our Comminge, and not far from the Pyrenees Mountains, there was a subterranean place too, neither as large nor as dark as this one, where again were found the Venus idol

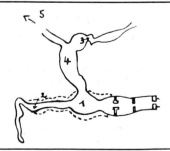

1 GREAT HALL OF BULLS
2 AXIAL GALLERY
3 SHAFT
4 NAVE
5 TOWARD THE CHAMBER
  OF FELINES

13 Ground plan of the cave of Lascaux.

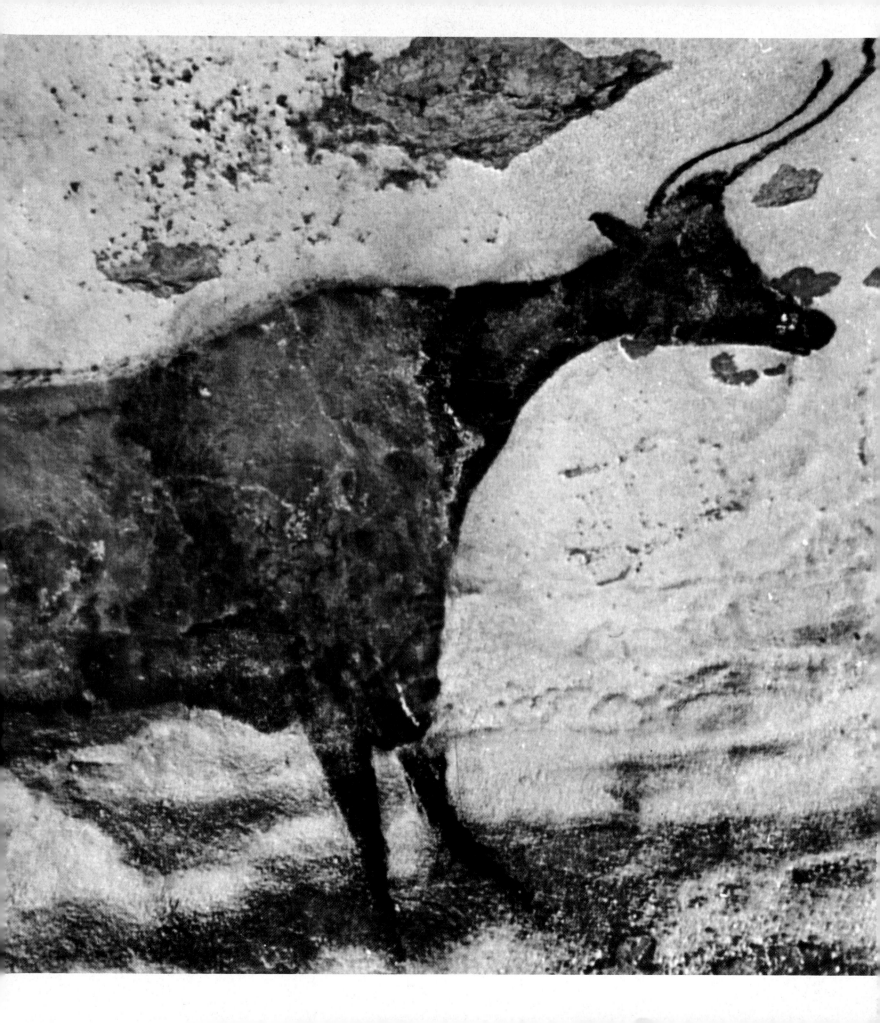

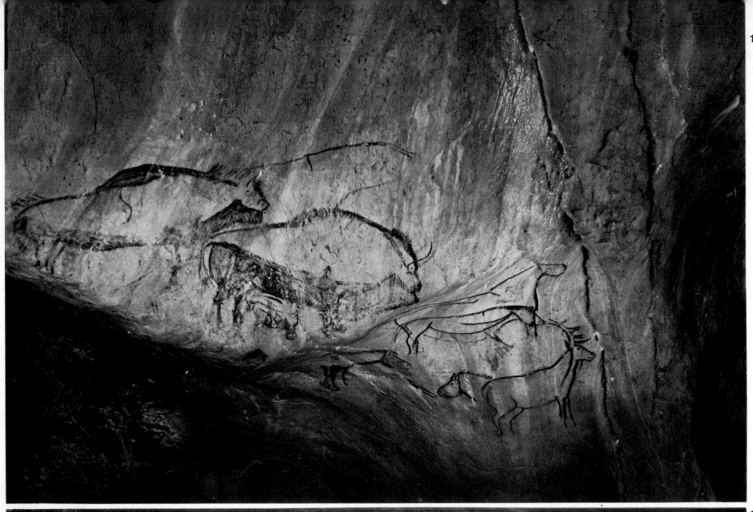

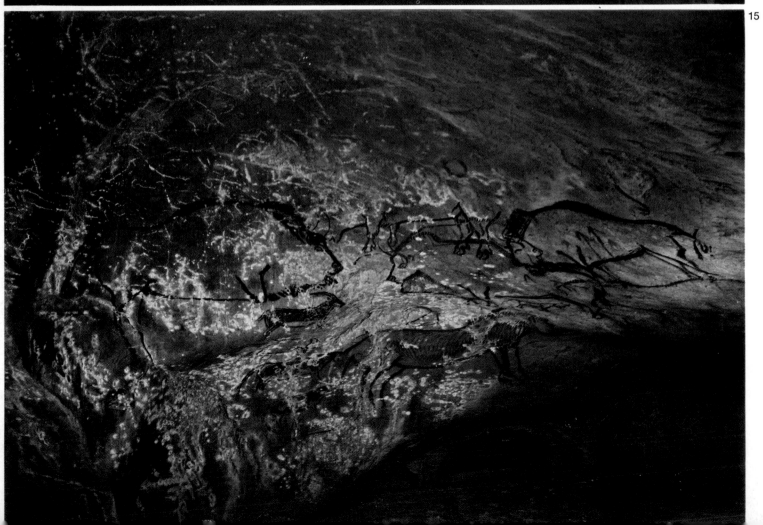

and innumerable figures of Priapus and other obscenities. . ." (*La Cosmographie universelle de tout le monde*, vol. I, cols. 198-199).

Périgord and the Pyrenees: the caverns of these two centers of Upper Paleolithic mural painting indeed sheltered "obscenities," along with human figurations and sexual signs, although in fact the art is far richer in representations of animals, of which Belle-Forest mentions only animal "traces or footprints."

The prehistorians themselves recognized the mural art only after the tools and decorated objects — the "art mobilier" — had formed the basis for a knowledge of prehistory. The first prehistoric objects to receive serious attention were the famous "thunderstones," so called because they had originally been presumed to be accompaniments of lightning. The "stones" included fossils and prehistoric implements. In 1859 the Frenchman Boucher de Perthes and English geologists established that the thunderstones and fossilized remains of extinct species existed in the same levels of archaeological excavation and were indeed contemporaneous. When decorated pieces were found in the same relationship, it was an easy step to attribute their creation to the same peoples who had already been shown to be capable of fabricating useful objects. There was no objection to combining in the same person the skills of the tool-maker and those of the decorator of harpoon or plaquette: the genuineness of the "art mobilier" was thus readily accepted.

The mural paintings were quite a different story. Painting, held to be one of the great arts, did not seem within the reach of men still armed with stone axes. The earliest discoveries of the great cave painting preceded the climate of opinion which could have appreciated them; they were ignored, or treated with the most severe skepticism.

The case of Altamira is classic. As early as 1863 a Spanish hunter had spotted in the cave of Altamira the black drawings which were to be rediscovered by Don Marcelino de Sautuola in 1875. An amateur prehistorian, de Sautuola explored the outer rooms of the cave for several years until, in 1879, a little farther along in the caverns, his little daughter Maria lifted her eyes, according to legendary account, and exclaimed, "Toros, toros!" at the sight of the grandiose polychrome ceiling. She had found one of the major masterpieces of Upper Paleolithic art (Fig. 10.) But de Sautuola exposed himself to endless rebuffs when he spoke of the paintings of Altamira to students of prehistory. By 1883 Harlé regarded as authentic only the engravings and black drawings in the outer rooms (Fig. 7.) not the magnificent coiled bison. The Marquis was hatefully attacked. In 1887 he was supported only by Vilanova y Piera in Madrid and by Piette and Chauvet in France. Only the two latter mentioned painting as such: Piette in his discussion of the beginnings of engraving and sculpture, and Chauvet in connection with the horses of the Quaternary. Not until 1902, after the death of de Sautuola, did expert opinion begin to reverse itself, with the presentation of Cartailhac's famous "Mea Culpa of a Skeptic" at the Congress of Montauban. ("Les Cavernes ornées de dessins: la grotte d'Altamira. Mea culpa d'un sceptique." L'Anthropologie.)

In France itself matters proceeded somewhat differently. In 1878 a schoolteacher from the province of Ardèche, Léopold Chiron, had noticed deep lines on the left of the vestibule of the cave of Chabot in the province of Gard. He did not succeed in drawing attention to them; indeed the figures were not very legible. Representations of animals equally difficult to decipher were revealed in various other caves in the Ardèche, such as Le Figuier, before 1890. Serious studies, however, began at La Mouthe, near Les

---

*14-15  Niaux (Ariège), Salon Noir. Two scenes from the great panorama. Top: Very fine standing stag (Cervus elaphus). The simplicity of the means—black line drawing without filling—is surprising. There is a poetic quality in this animal landscape that betokens complete mastery. Bottom: Superposed bison of precise draftsmanship; cervids.*

---

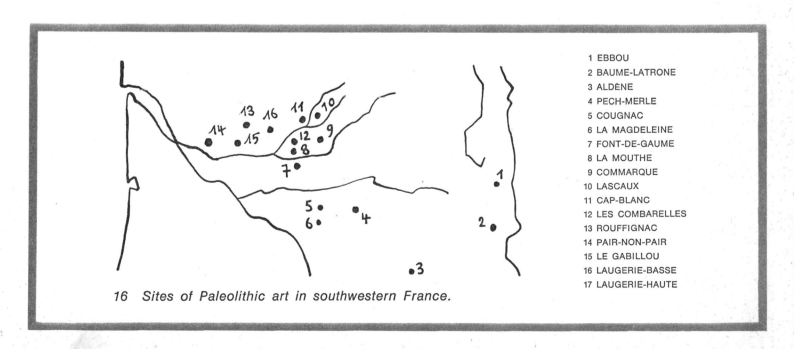

*16  Sites of Paleolithic art in southwestern France.*

1 EBBOU
2 BAUME-LATRONE
3 ALDÈNE
4 PECH-MERLE
5 COUGNAC
6 LA MAGDELEINE
7 FONT-DE-GAUME
8 LA MOUTHE
9 COMMARQUE
10 LASCAUX
11 CAP-BLANC
12 LES COMBARELLES
13 ROUFFIGNAC
14 PAIR-NON-PAIR
15 LE GABILLOU
16 LAUGERIE-BASSE
17 LAUGERIE-HAUTE

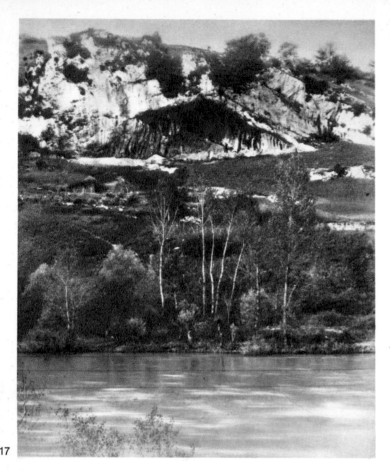

17

18

Eyzies in the Dordogne. Here young Gaston Bertoumeyrou found, some two hundred yards from the cave entrance, a very recognizable engraving of a bison. He notified Emile Rivière, who presented an earnest but little-heeded paper on the find to the Academy of Sciences. Rivière did something else: he invited Henri Breuil, a young priest then twenty-three years old, to make tracings of the engravings at La Mouthe. Thus in 1900 began not only a cascade of explorations, but a career unmatched in the field of pre-history. The vast body of facsimiles produced by the Abbé Breuil throughout a lifetime of investigation are fundamental to the science of prehistory to this day.

The beginning of September, 1901, marks a turning point in the study of cave art. The decorations at Les Combarelles were discovered on September 8th by Breuil, Capitan and Peyrony; on the 16th, Peyrony found those at Font-de-Gaume. The Congress of Montauban paid mural art an official visit at Les Eyzies on August 14, 1902, and in the same year Cartailhac and Breuil set out to record the works at Altamira. The painted, so-called "mutilated" hands at Gargas, first noted by Félix Regnault, inaugurated the finds in the Pyrenean region (Niaux, 1906; Le Portel, 1908), and the forms of Franco-Cantabrian art continued to be revealed in the works of La Pasiega (Spain, 1911) and Les Trois-Frères (Ariège, 1912-1916).

The multiplication of discoveries did not, until the "invention" of Lascaux, open prehistoric art to the general public. In September, 1940, eighteen-year-old Marcel Ra-vidat and three school friends explored an ancient under-ground opening — following, according to legendary account, their dog — and came upon the most famous and certainly

most widely publicized of the galleries of prehistoric painting. From this day on, the crowd has entered the sanctuary.

The heroic phase of the great Franco-Spanish exploration, when the prehistorians frequently discovered frescoes themselves, has been succeeded by a period when, having received information, very often from speleologists during the last thirty years, they go on to check and supplement the findings. Spurred by reports, they have thus proceeded not only to Rouffignac and Villars in the Dordogne, but all the way to South Africa.

---

17   *The site of La Colombière (Ain).*

18   *Laugerie-Basse (Dordogne), Abri des Marseilles. Overhanging limestone cliffs. The road at their base has broken up the ancient soil.*

19   *Lascaux (Dordogne). Composite animal known as "The Unicorn". It appears that the horns attributed to it are simply the tail of the large bull that precedes. It has a square masklike head, ocellated spots, and an enormous belly. Variously identified as a Tibetan ante-lope, as the god of the cave, etc., this monster, like the scene in the Shaft (Fig. 22), is the subject of an abun-dant but not very conclusive literature. In the lower right-hand corner Abbé Breuil examines the panel.*

20   *Niaux (Ariège). Forequarters of a horse. The mane and beard are rendered by thick hatchings. The neck is stretched forward at an angle reflecting that of the legs.*

---

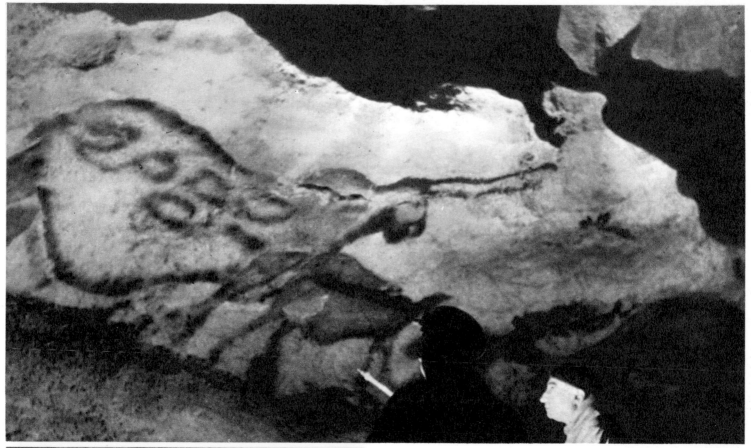

19

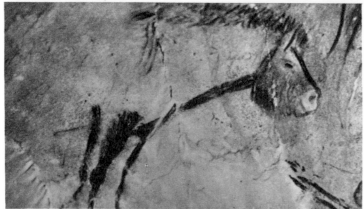

20

## Classic Interpretations: Art and Hunting Magic

The area from the south of the Loire to the Cape of Good Hope represents the immense and, as far as is known, the sole region of Paleolithic mural painting. Breuil called this "the favored time zone." Certain works in Asia and America cannot yet be related to this ensemble; no sure connection, moreover, has been established yet between Franco-Cantabrian art and either the art of the "Spanish Levant" (the area between the Pyrenees and the province of Murcia) or the African rock painting which was still practiced in many instances as recently as the nineteenth century. Of all these styles, Franco-Cantabrian art, with its extensions in southeastern France and southern Italy, presents itself as the most ancient and the most homogeneous.

This art is above all a powerful animal art, although it executes also two other types of figurations, one human or anthropoid, the other more abstract: wavy bands, rows of dots, series of variously disposed lines, ovals, arrows — in short, "signs." And although the aims of the artists elude us, we feel that these exist: it is an animal art that assuredly does not content itself with merely representing animals. The animal representations have very definite characteristics. In the first place, sheer abundance. In any one of the hundred or so decorated caves currently inventoried, horses, bison, bulls succeed one another in endless processions. They are not all associated individually with signs; hence the number of signs remains much lower than the number of animals. The human or semi-human representations, whose rarity has been overemphasized in the face of their growing list (Les Trois-Frères, Lascaux, Villars, Cougnac, etc.) are nonetheless rather few.

Quantitatively then, the mural painting depicts primarily animals. And qualitatively, it distinguishes them by an obviously preferential treatment. Their execution, compared to that of the other figurations, reveals remarkable care, tautness, and finish. The human figures conspicuously lack the rich documentation that surrounds certain other zoological species, which are meticulously described, lavish attention often being given to an expressive fold of the jowl or to the way the fur lies. We look in vain for a

well-poised, life-size human figure, illuminated by truly descriptive details, whose placement would have the monumentality of one of the bulls of Lascaux. Unfortunately human beings were not painted from the same viewpoint as animals. Man remains an incomplete, often grotesque figure, rendered in line, distorted willfully, it would seem, by masks, and always isolated, clandestine (Fig. 25.) His presence is a furtive, marginal one (Figs. 2-5). It does not interest the artist. Only for animals does he draw on all the resources of his craft.

In the animal paintings are unfolded the potentialities of an art capable of conveying the attitude, the movement, the mass of a living world which might appear singularly restricted in content but for the copiousness of the fauna and the intensity of the works. Here, then, is a civilization for which the animal is the only reality worthy of creative art. This reality presents itself with such dignity that the word "sanctuary" has seemed natural. Why this choice?

The first students were divided between two kinds of explanation: hunting magic and art for art's sake. Some indeed accepted both, believing that utilitarian rites cannot account for the sum total of motives. Drawing a picture for purposes of sympathetic magic, for example, Upper Paleolithic man might have been induced to endow it with those immediately profitless values that constitute "great art." In his lyrical preface to *Four Hundred Centuries of Cave Art*, Breuil speaks of a sort of mystical promotion of the ideal: "... for the first time men dreamed of great art and, through the mystical contemplation of their works, gave their contemporaries an assurance of success in their

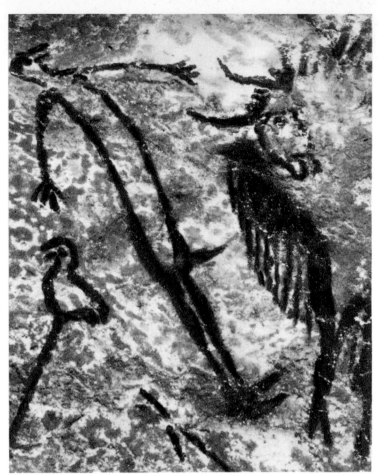

22

"great hunt," though the achievements of painting might go beyond the requirement of hunting magic. He liked to say that only those peoples who lived by hunting and, collaterally, by fishing, had practiced this art. With zest he contrasted these virile tribes with the sterile "snail gatherers." Indeed his "time zone," from the borders of the Vézère to Bushman country, contains none but hunters, and the survivors of prehistory who practiced rock art in the rest of the world until recently are hunters too.

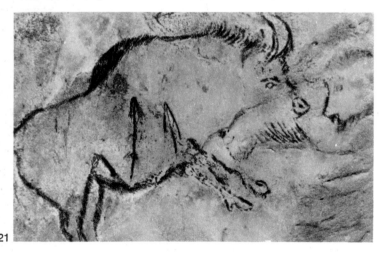

21

expeditions, of triumph in the struggle against the enormous pachyderms and herbivores ... thanks to men of genius was discovered the immense social impact of these works apparently devoid of any practical aim, by which Humanity, as it gained confidence, could free itself from the all-absorbing cares of a vulgar and banal, albeit dangerous, existence; it found for the first time in art ... an art devoted almost exclusively to animal life, that apparently useless silken ladder which allowed it, by a spiritual dream sustaining existence and developing a moral sense, to sink into the immense contemplation of that which, invisible, dominates the Cosmos."

Other less grandiloquent texts make it plain that Breuil saw a direct link between the mural paintings and the

*21   Niaux (Ariège). One of the bison in the Salon Noir, outlined in black with a brush. The draftsmanship is remarkable. Two arrow-wounds mark the flank.*

*22   Lascaux (Dordogne). Detail of the scene in the Shaft. The man, schematic and ithyphallic, falls backward before the charging bison. The style is poor. Note that the head of the bison is not properly positioned.*

*23   Lascaux, Nave. Male bison back to back drawn in absolute profile, rare in this cave. The filling is very dark brown. The red spot on the flank of the left-hand bison indicates the springtime shedding of the coat. A tearing movement carries the animals in opposite directions. The small hooves seem to strike the ground.*

*24   Lascaux, Great Hall of Bulls. One of the small cervids between the large black bulls. The antlers are in so-called twisted perspective.*

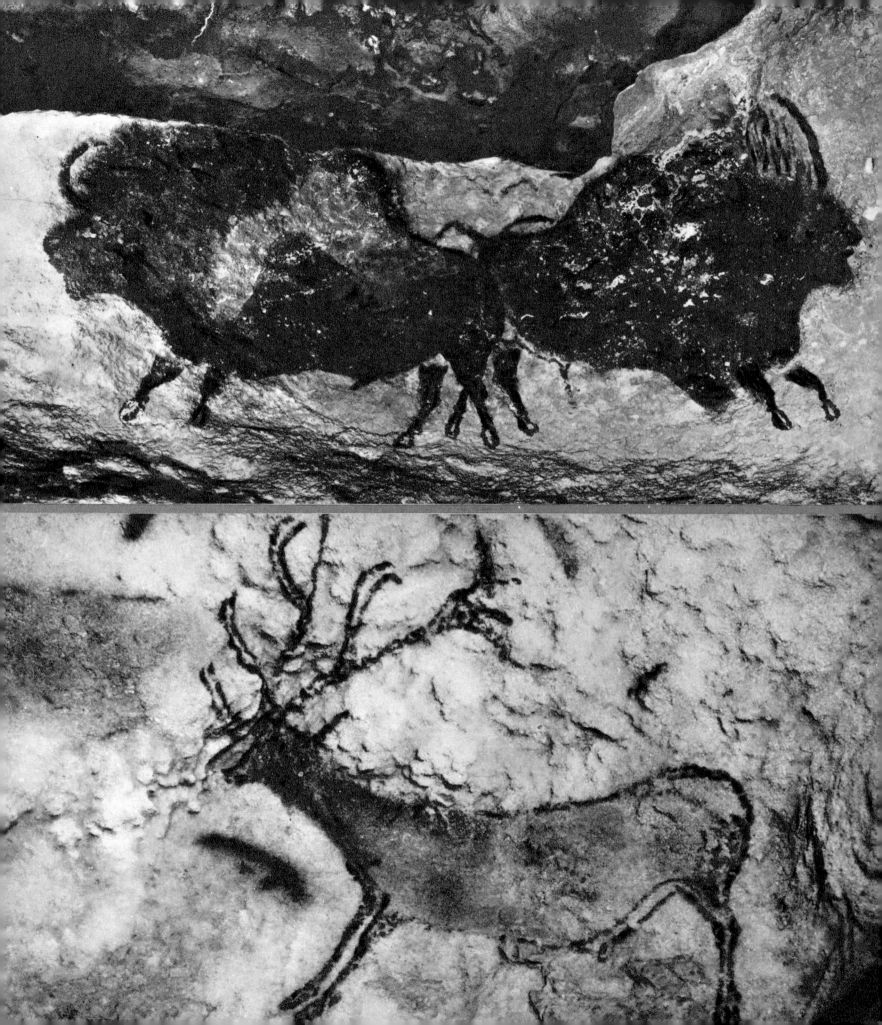

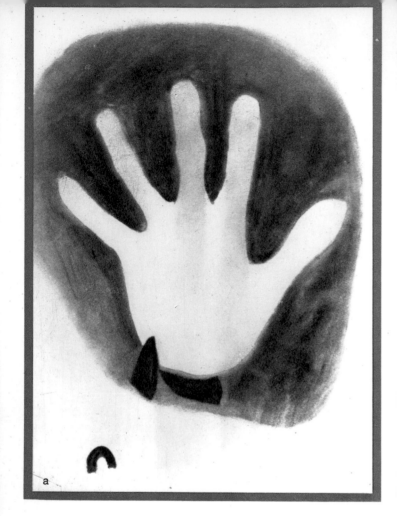

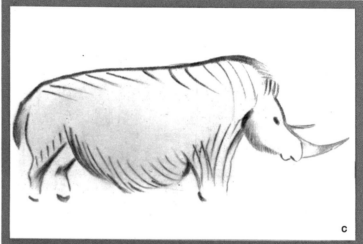

The hunting magic theory is inspired, of course, by comparisons with anthropological studies of "primitive mentality" in surviving tribes of hunting peoples. "Hunting magic" is of two types. First, "rites of sympathetic magic," whereby the image produces the act, that is, whereby the representation of the wound provokes the death of the prey. Pictures of wounded animals are numerous in the caves (Fig. 21.) Second, "rites for the multiplication of game," an explanation that justifies the presence of intact animals — for only about fifteen percent of the animals depicted bear unmistakable wounds — and accounts for the pregnant females, of which there are obvious examples, even though not all large-bellied animals can be taken as on the verge of dropping young.

It is relatively easy to ridicule an early interpretation by insisting on its purely hypothetical nature. Obviously one cannot, without romanticizing, deduce the ceremony from the setting or the rite from the document. Well-preserved tracks of adolescents on the floor of a cave do not necessarily or even probably signify an initiation. Perhaps the most explicitly suggestive works of art are the clay bears at Montespan, pierced with numerous holes; yet we cannot infallibly recreate on the model of later cultures a series of specific acts — the riddling of statues with spears, the

*25   A series of Paleolithic paintings and engravings.*

*(a)   Negative hand. It may have been executed by the blowing technique, even though the proportions of the fingers appear abnormal.*

*(b)   Mammoth, copied by Breuil.*

*(c)   Font-de-Gaume (Dordogne). Rhinoceros in red line at the end of the main gallery. Length: 28 in. (Breuil.).*

*(d)   Altamira (Santander). Polychrome hind on the ceiling. (Breuil).*

*(e)   Altamira. Galloping horse. (Breuil.)*

*(f)   Altamira. Unfinished polychrome horse, 5 ft. 3 in. long, superposed on a red hind in flat wash. (Breuil.).*

*(g)   Altamira. A polychrome bison on the ceiling.*

*(h)   Altamira. A galloping bison painted in black with a little color.*

*(i)   Altamira. A coiled polychrome bison.*

*(j)   Font-de-Gaume. Brown and reddish brown reindeer with alternating bands on the thigh. Length: 3 ft. (Breuil.)*

*(k)   Les Trois-Frères (Ariège). "The Sorcerer", a strange semi-human representation engraved and painted in black. Height: 2 ft. 5 in. Note the lively round eyes with pupils; the stag's ears and powerful antlers; the absence of a mouth; the long beard; the forearms ending in joined hands; the human feet; the lavish tail; and finally the very distinct sexual organ, which is directed backward.*

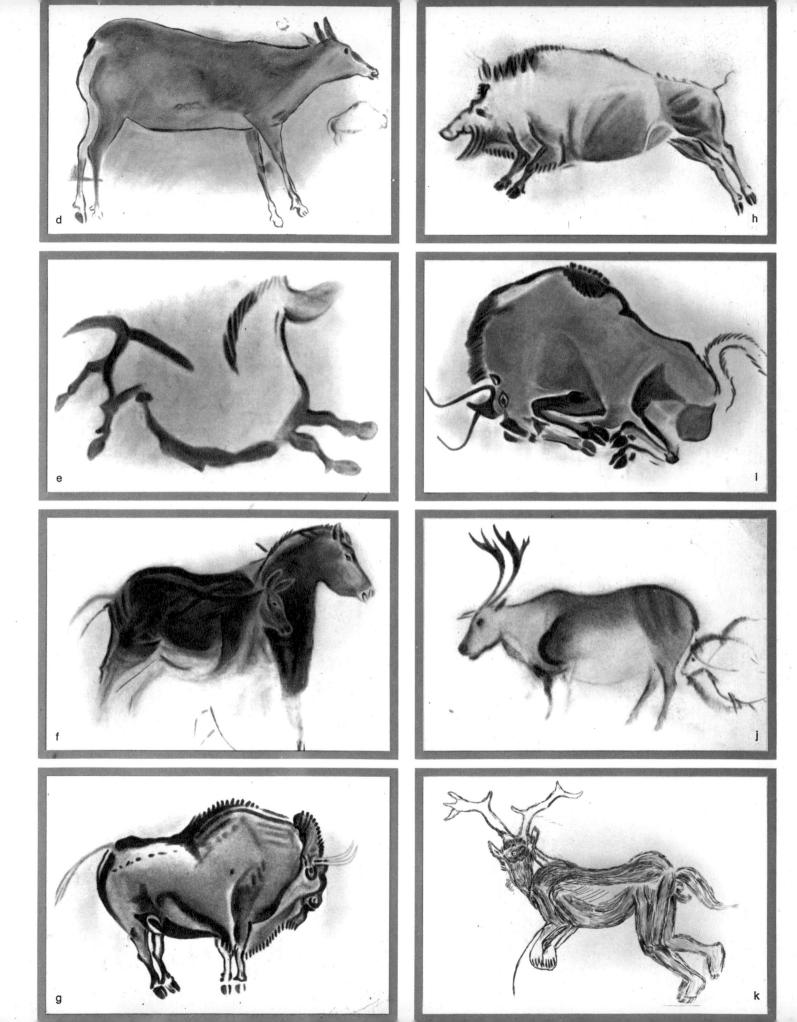

d

h

e

l

f

j

g

k

clothing of clay bodies in skins, the attaching of a real head to the neck of an animal figure which lacks one. We can only say that after all, the silent testimony does not prove either that the rites did not exist. One may assume that certain practices in the caves were connected with hunting. Granted such practices existed, how can they explain the art?

Let us state here that the bears of Montespan, rather crudely modeled and, according to Breuil, "half ruined" or "pulled to pieces by the Magdalenians themselves," are not among the consummate works of art. Hence they would fit rather well into the category of objects intended for use in sympathetic magic, where the works, generally rudimentary and perishable, aspire only to an approximate resemblance. To connect painting with hunting, it was necessary to posit, in addition to sympathetic magic, rites for the multiplication of game. The decoration of the caves — "dream of an immeasurable abundance" with its numerous and varied animals, not all of them wounded or pregnant — presented itself in successive layers, the oldest in black line, others modeled in red, still others in several colors: each group of animals presumably corresponded to a new period of artists who superposed their works on those that came before.

A different ceremony may have been linked with every wave of artistic execution. It has also been considered possible that a background layer was spread each time to mask earlier decorations. On the basis of Australian models, it has been surmised that the interposed layers may have been composed of oxidizable materials, such as blood, which after their disappearance in the course of time would reveal the various levels of art work as superposed and entwined animals. In other cases, the older figurations seem clearly to have been respected or retouched rather than covered over.

The "hunting magic" theory of the frescoes — a subject of lively discussion at present — related them to pressing social imperatives whose guiding poles were success over the hunted animal and the fertility of the flocks. This interpretation has been largely discredited, but its followers have been on unassailable grounds in recognizing, as they were the first to do, that the painted cave was a sanctuary. This impression was inescapable in the great ensembles. It was easy to see that the decorated caves had never served as habitations. No hearth, no carving or kitchen debris, could generally be found in them. A very few weapons and tools, some lamps as at La Mouthe or Lascaux, some traces of hands, and some scaffolding perforations, together with ochre pencils and stone palettes, made up more or less the sum of the artifacts. Particularly the Salon Noir at Niaux, and the Hall of the Bulls and the Axial Gallery at Lascaux, offered compositions so impressive, of such gravity and power, that these places could have served only as specially chosen repositories for the secrets of a civilization.

Some rock shelters and secondary galleries, and even some of the sites with engravings and sculptures, have a content which is broader and freer so that they appear more familiar, more profane, more human in tone. But the great painted frescoes put us into the presence of realizations so heavily charged with emotion, of such incontestable importance, that they immediately attain to the level of the sacred. We feel this, just as we would feel it if we had discovered the remains of the Parthenon or the frescoes of the Church of Saint-Savin in the absence of any written or archaeological context. In the same way, we should know without hesitation that in these places men would not have employed such an artistic idiom if they had simply wished to make a hangar or a dance hall.

We should not, however, have the means of reconstructing the forms of worship of the Greek city-state or of Christianity in the Romanesque period from such an isolated discovery. Fortunately, even for prehistoric art far more than one sample of the creative force of the civilization survives. Time does not have complete power even over material things. Those who admire Lascaux too exclusively, fascinated by the exceptional splendor of the figures which generate an atmosphere of wonder, are mistaken in viewing it as the only revealing miracle cave. All the caves share this awesome quality to a certain degree and speak the same language. The mural painting is disseminated among many sites that, to judge from those known to us, constituted a whole obeying the same imperatives to a remarkable extent and manifesting a singular unity of inspiration. The great interest of the art forms for the societies of that time is demonstrated by the repetition and the quality of the works. Their tenacious pursuit of an end presents itself in each cave with the effect of an obsession.

A little oppressed in these subterranean places, we expect to find at the very least strange gods there. What we mainly see are mammals. Thus the powerful impact of the mural painting leaves a somewhat embarrassing mixture of impressions: agreeable surprise before an accomplished expression of values felt to be of capital importance and the realization that we do not understand these values. The beauty and also the bearing, the disposition of the figures in this abnormal, somewhat hallucinatory space reaches us directly, while their meaning escapes us. An aspect of the animal world that has become unintelligible to us dominates these pictures. We easily forget, after the immense struggle for domestication and the almost total destruction of the species represented in the frescoes, that animals once exercised a true sway over the same territories as man. Guided by their infallible instinct, they found as masters the subsistence that man had to conquer by conscious laborious detours. The blind and sure freedom of the powerful herds could appear a divine dispensation of nature to human beings left naked and feeble before forces set in motion by the very momentum of life. Man was first bound by the necessity of fashioning an equipment — weapons and tools. Intelligence, after having compensated by cunning and efficiency for an inferiority to animals, found in them the subject of its imagination.

It is this relationship of which the mural art gives us an inkling. Fear is hardly present here, rather a kind of

---

26 *Pech-Merle (Lot). Mammoth in black line with long hairs covering the trunk and legs. Note the fine line from head to tail.*

---

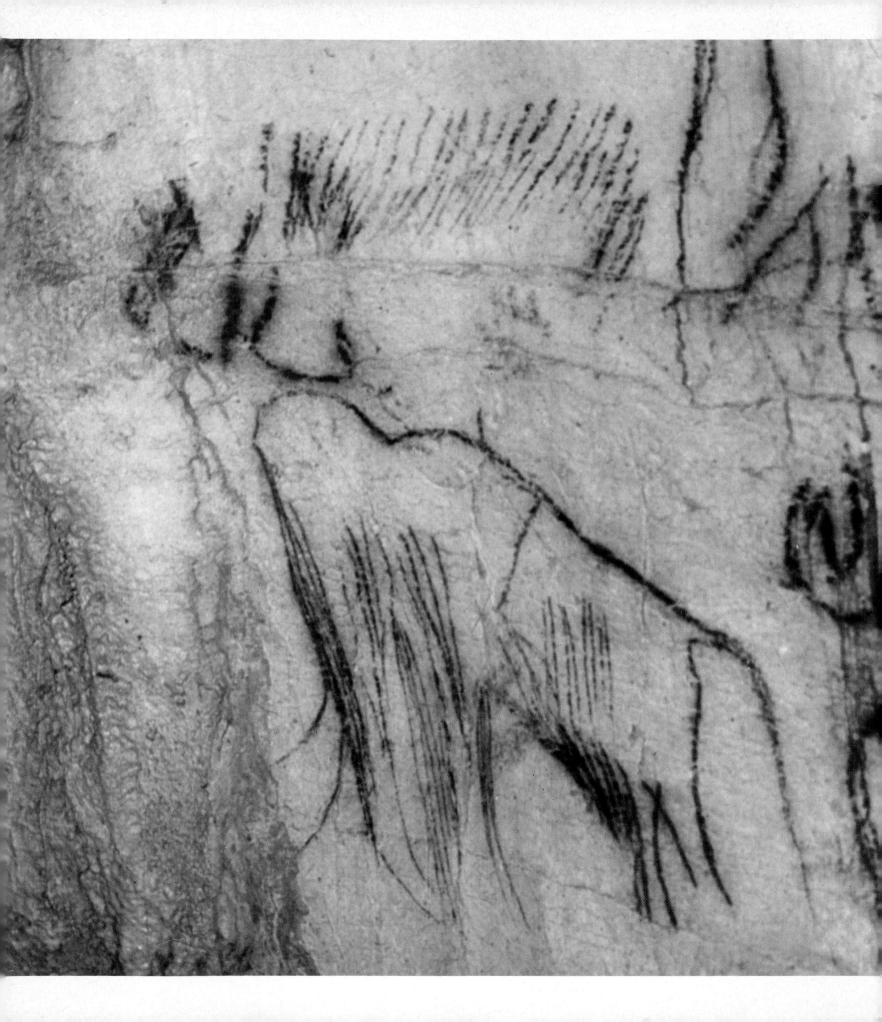

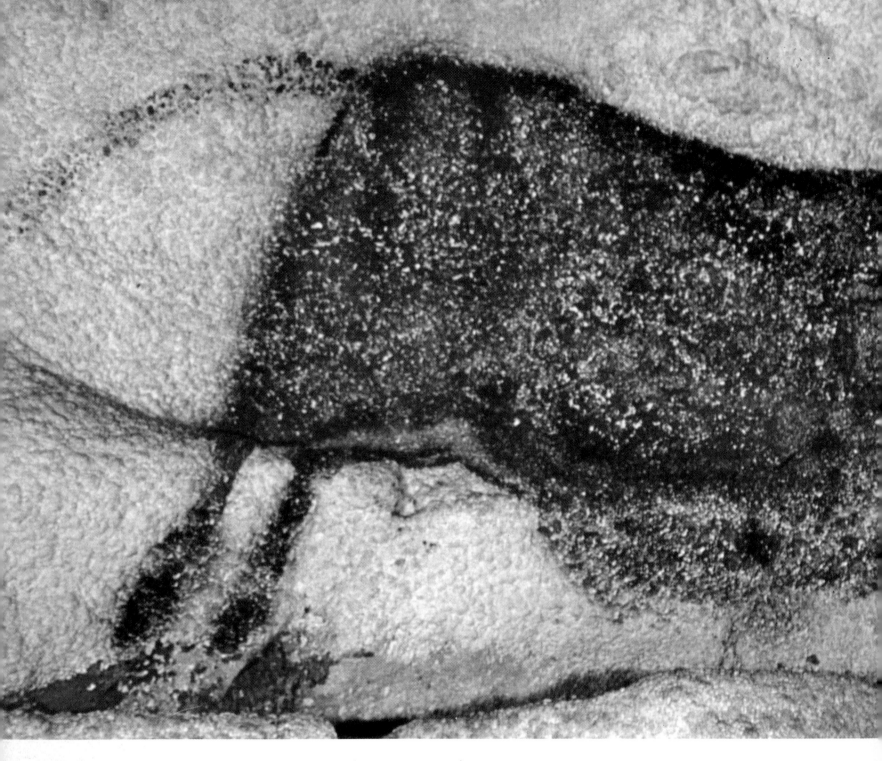

admiration. Species that were truly man's rivals were not very numerous, with the exception of the bear and the little cave lion, which disputed him his home. Eminently edible, the fauna is never evoked from that point of view; the obsession with animal representation is on a plane far beyond the idea of meat. The pictures cannot be placed on a level with material necessity. In avoiding too lowly an explanation, there lies a risk that one will be at a loss to account for them at all unless one gives them a religious motivation. The idea of an Upper Paleolithic religion thus stemmed directly from the existence of the sanctuaries.

It was extremely difficult to define this religion. Nothing in the nature of the figurations indicated that they re-presented divinities: these bison, bulls, and horses look very much like bison, bulls, and horses. In this balanced icono-graphy, there are no monsters, no symbols of power or perversity multiplied in a suspect manner. Paradoxically, it is in the painting outside the sanctuary, in connection with the little female statuettes, that one may speak of idols. As to the human representations in mural art, they appear at too many different and subordinate levels — from "little masks" to disguised or wounded men — to be those of central deities.

The art of the Age of the Reindeer seems to have left none of the symbols of nature — sun, moon, stars, allegories of the alternation of day and night, of the return of the

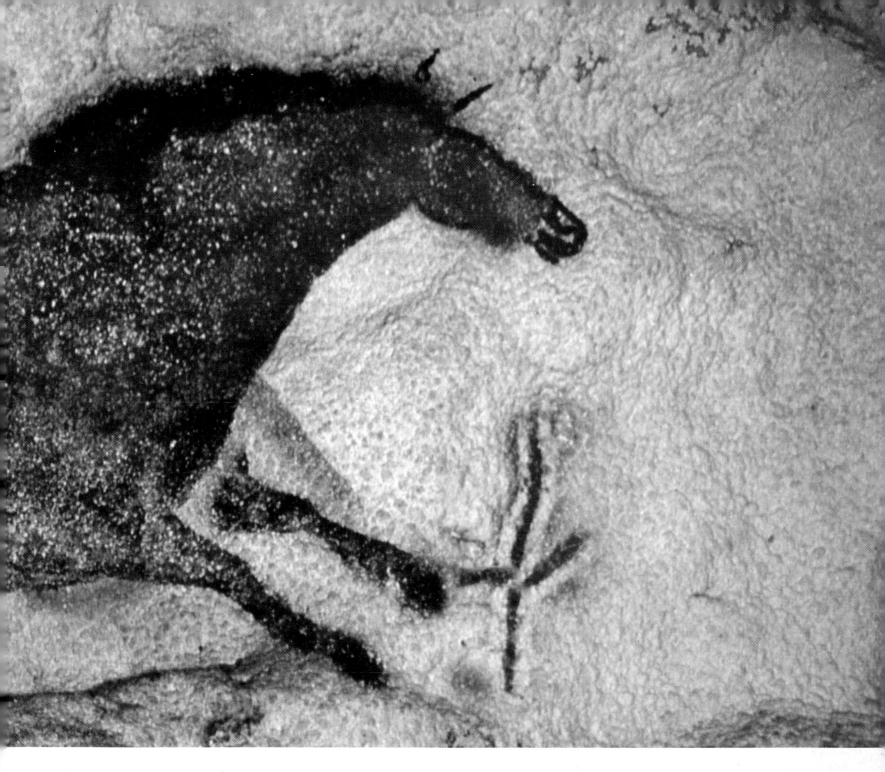

seasons — that abound in agricultural civilizations, for example. The cyclic phenomena are of special importance to religions whose calendars regulate agricultural labors, but they ought not to be indifferent to hunting peoples. The arrival of the herd according to its seasonal migrations may have served as a point of reference in the passage of time. In this case, the presence of the animals could have made manifest a stable order in the universe and become the symbol of that order. The impossibility of proving this purely hypothetical association, whereby the cave would be, if not a reflection of the world, then at least a calendar, shows how little we are able to reconstitute a religion from the representations themselves.

*27 Lascaux (Dordogne). Superb galloping horse at the end of the Axial Gallery. Length: 9 ft. 10 in. The bister coloring becomes black at the nostrils and mane. Note the smallness of the head and the delicacy of the muzzle. In front is a barbed sign in which Breuil saw the negative silhouette of a child's arm. The cloudy mane was done by the blowing technique.*

## New Theories: Analysis of the Signs

The "hunting magic" theory had been endorsed, not without caution, by Abbé Breuil in the beginnings of the discovery of prehistoric art. After fifty years of speculation, an impasse was reached. Falling back on the animal in every case did not advance interpretation. At this point, a sudden shift of opinion occurred that was to renew the study of prehistoric art. The idea of studying the figures no longer in themselves but in their associations, must be credited to Mme. Leming-Emperaire, who set it forth in her thesis on the meaning of Paleolithic art, and to Professor André Leroi-Gourhan, who in 1958 laid down the statistical principles in two widely noted articles, which he followed with works of considerable scope. The time had come, after the organization of a vast inventory of forms by the pioneers, to reconsider quite literally the point of view from which they had perceived the figures.

Here, in order to explain the perspective of the early prehistorians, it is necessary to recall the conditions under which the discoveries were made. The examination was begun gropingly, moving from one figure to the next or from one group to the next. The representations of animals inventoried one by one retained a character of isolation. The pattern of the unity of perception of the prehistorian was imposed on the composition: the panel as a decorating surface was the largest unit considered. The sum of the representations in a cave came down to a simple addition of figures or groups of juxtaposed figures. The second step consisted in distinguishing in the superpositions, or even in the sequences, the older phases from the others. These analyses, to which Breuil gave all his care, were based primarily on stylistic criteria, of which we shall speak in connection with the dating of the paintings. The stylistic categories were multiplied to the point where the decoration of Lascaux, for example, was divided into fifteen chronological stages, if not twenty-two, from the not very legible "little child's arm bordered with faded red color" to the "two great figurations of superior execution" in uniform brownish black, situated in the Axial Gallery (leaping cow and bull).

Everything changes if the representations in a decorated cave are considered all together, and, instead of being viewed as decorative accumulations separated by centuries, they are regarded as the roughly contemporaneous products

of a single campaign of execution. In this case, they may be taken to form a composition; it then becomes possible to study their interrelationships as in any other iconographic ensemble. The significant point is that these interrelationships present various constant features which are revealed by statistical studies. Working on 2,188 animal figures divided among sixty-six sites chosen from the one hundred and ten known caves, Leroi-Gourhan first verified in precise fashion, with the help of data-processing procedures, the already observed distinction between the types of animals

28  *South Africa. Note in this antelope the very effective use of white and the length of the rear legs.*

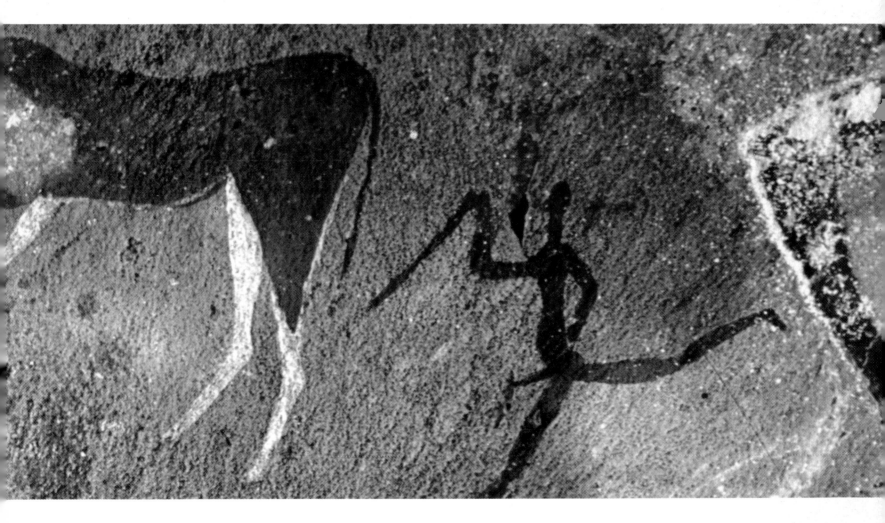

(bison, horses, oxen) depicted in central areas, and those which appear in entrances, passageways, and remote sections (small herbivores, dangerous animals, etc.) A more surprising set of relationships then became apparent: for certain groups of figures, complex associations are repeated from one cave to another and sometimes more than once in the same cave. This implies leitmotifs of a sort, constantly re-used by mural art. Leroi-Gourhan's statistics revealed associations between certain animals — "bison-horse" for example — or between animals and other representations — "bison-woman" and "man-horse." In these combinations a basic role is played by the constant notion of values at once opposite and complementary: male and female values.

Thus all representations, including signs, are assigned parts in a vast game where they balance each other in abstract fashion.

For the signs, this treatment of abstraction is partly new, since previous investigations tried to see them mainly as schematic pictures of real objects: huts, weapons, marks of wounds. The possibility of abstract and symbolic expression in the Age of the Reindeer had been accepted for the category known as topographical signs — rows of dots,

colored marks at crossings or near dangerous spots (Niaux) — and for the "blazons" (Lascaux.) But the new theory supported a whole metaphysic by extending abstract significance to all signs. Thus the portrayal of real animals by the prehistoric artist becomes a particular manifestation of a vast output directed entirely toward an almost doctrinal presentation of the principle of a duality of nature.

The originality of Leroi-Gourhan's work does not lie in his having substituted another hypothesis, one his adversaries describe as "pan-sexuality," for those of magic and art for art's sake. It lies in perfecting an approach that attempts to bring some order to the mural decoration. The assumption that the paintings reflect an iconographic plan gives one at least a chance to organize them by analysis. Leroi-Gourhan has chosen to explore this way out of the impasse; the cave then becomes for him the same kind of puzzle that a cathedral might be to a Martian.

Leroi-Gourhan's very handsome book, *Préhistoire de l'art occidental*, now the subject of lively discussion, is certainly fundamental to the future of the discipline. All the same, analysis cannot proceed as mathematically as one might suppose from the computor language used in his "Documentation." Definitions sometimes assume the problems to be already solved; some of the remarks bearing on the coefficients introduced in the statistical tables are not clear. The computing sometimes leads to curious evaluations, as when the theme of the horse is counted as unity if it occurs in one cave, no matter how many times, but as two if it occurs in two caves. On the ceiling of Altamira the more than fifteen bison are assigned a numerical value of

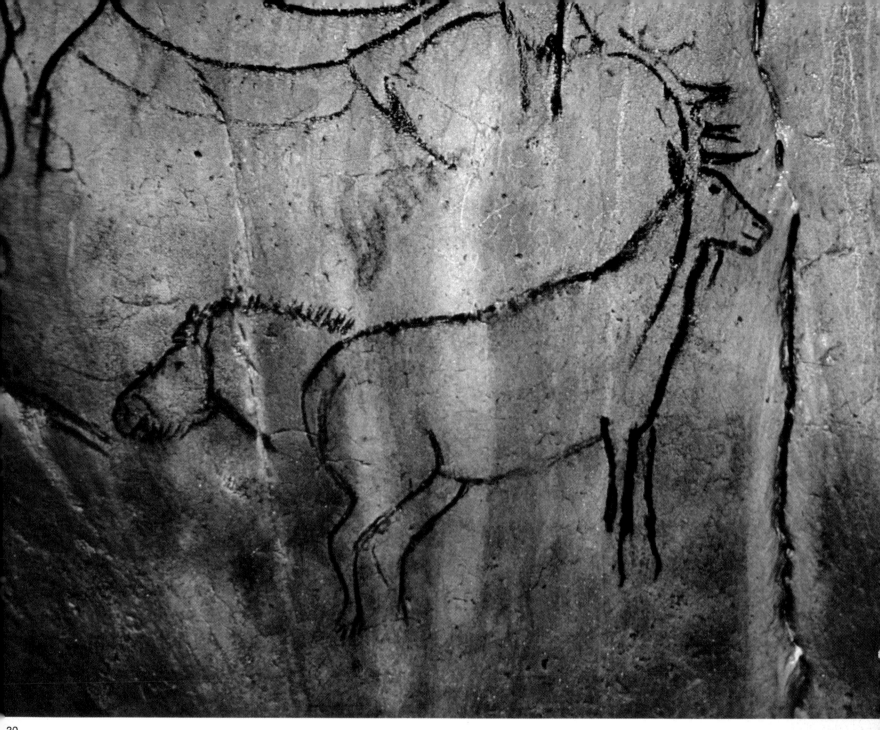

29 *Font-de-Gaume (Dordogne). This horse's head is excellent despite the thickness of the somewhat blurred red line. Often placed near unusual topographical features, horses' heads seem to have a special significance, so far unexplained. Three are found at Lascaux: in the Shaft, at the end of the Axial Gallery, and in the Great Hall of Bulls.*

30 *Niaux (Ariège). Stag (Cervus elaphus) in rather thick black line on one of the two right-hand panels in the Salon Noir. Length: 3 ft. 3 in. In this very elegant drawing the artist seems to have been intent chiefly on capturing the nobility and grace of the pose. The treatment is less detailed than in the large left-hand panel, where, among other features, the coat—not depicted here—is very precisely indicated. A horse's head with a stiff mane, and in a good style, is on the left. On top is the lower portion of two superimposed animals (one of them a horse) of mediocre execution. The stag's antlers do not fan out: they are elaborated vertically. The extremities are neglected, and the eye is reduced to a large dot. The liberties taken with the absolute profile and the deviations from rigorous perspective, noticeable especially in the hindquarters, endow the body with a certain three-dimensionality. The head, less successful in this respect, is somewhat deficient in relief. Cervus elaphus is depicted relatively seldom in cave art, and generally alone (Lascaux, Altamira, etc.). This is the only representative at Niaux.*

one, but on the other hand, "the single mammoth of La Croze at Gontran is, in an absolute sense, as important as the several hundred mammoths of Rouffignac."

Leroi-Gourhan subdivides all animal figures into two categories, of male and female value. This division does not rest on any mathematical consideration, but is solely an attempt to parallel the dualism of the signs. Not by chance are the articles introducing the system entitled "The Function of the Signs in Paleolithic Sanctuaries."

The statistics of placement show only that female signs occupy central compositions and that male signs are more or less evenly distributed in all parts of the cave. From Leroi-Gourhan's analysis of the occurrences of given animal subjects in different parts of the cave, it appears that three animals are most commonly placed in the central locations: the horse, featured in 198 compositions, the bison in 148, and the ox in 46. The bison and the ox are considered to be animals of female sign, and they are supposedly balanced by the horse, an animal of male sign. But this balancing role in the central compositions is not entrusted to the other "male" animals (bears, felines, rhinoceroses), even though some — for example the mammoth — do seem to fulfill this function occasionally. In fact, the horse is ambiguous. Quite often, it leaves the central portions of the cave for the entrance or the rear, where it generally joins the stag. Bison and oxen are not often displaced in this way. The fact is that the horse is found everywhere, and its role remains a puzzle. A third, more flexible and broader category would

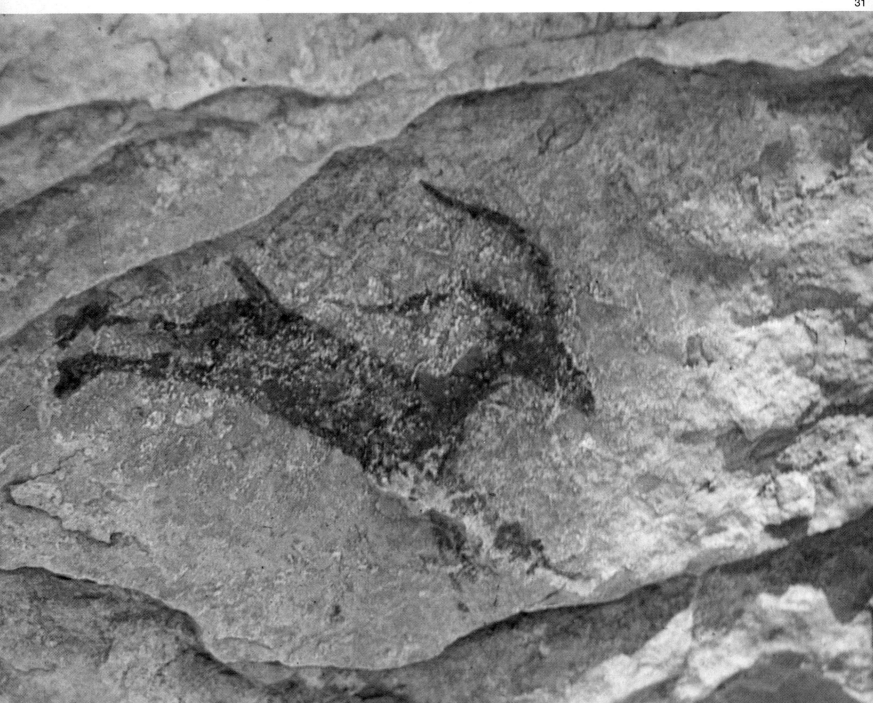

need to be created to resolve the polyvalent situation of this animal.

The placement statistics, then, do not entirely clarify the function of the animal representations. The division of all signs into male and female categories is somewhat simpler than the corresponding division of animals, for it can be based on an examination of a progressive series of forms. We know that such morphological series helped Breuil to show "the degeneration of animal figures into ornamental motifs," and that he uncovered through such studies many "graphic puns." In the present case it is difficult to interpret the series and regard as equally "female" the schematic silhouettes of women, representations of vulvas, ovals, brackets, tectiform signs, rectangular signs, etc. If wounds are female signs, arrows reasonably become male signs — but so do dotted lines, parallel lines, hooked signs, etc.

There often appears to be an arbitrary element in such series established by derivation from type; but for the male signs there has been a surprisingly precise demonstration of the relationship of realistic representation and abstraction. (Fig. 32.) In this case it happens that the decisive comparison between the decorations of the semi-cylindrical staff from La Madeleine and those of the perforated staff from Massat is of greater practical value for a demonstration of the system of signs in general than is mathematical analysis. Of course this pair does not reconstruct a morphological series, but it does clearly demonstrate an equivalence — in this instance, of the phallus and the

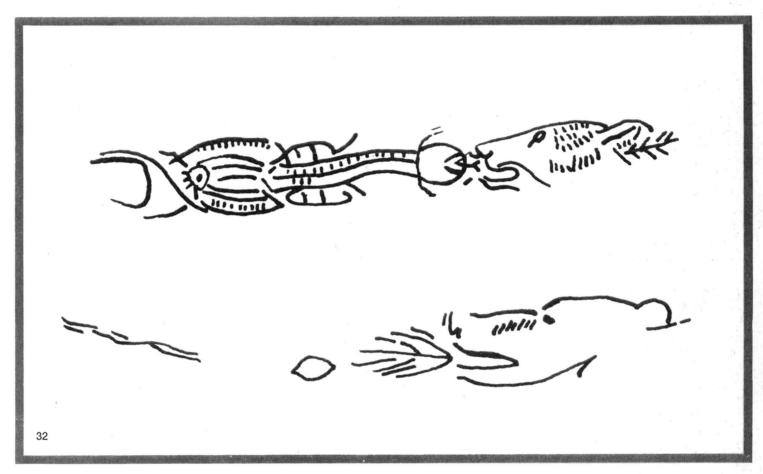

32

31 *Cervid.*

32 *Engravings of sexual representations and signs.*

*Top: La Madeleine (Dordogne). Engraved on a semi-cylindrical staff, bear's head with outstretched tongue in conjunction with a realistic representation of a phallus and a vulva.*

*Bottom: Massat (Ariège). Engraved on a perforated staff, bear's head in conjunction with a feathered (male) sign and an oval (female) sign. The theory that prehistoric man employed male and female signs corresponding to sexual representations—the basis of Leroi-Gourhan's system of explanation of rock art—rests in large part on the juxtaposition of these engravings.*

arrow sign. Thus Leroi-Gourhan finds his best argument, in entirely traditional fashion, in the comparative study of figurations on pieces of art mobilier.

Are we to conclude from this striking example that all representations and signs are interchangeable? On this question no determining evidence is yet available. The animal representations offer pictorial features so remarkable that it is hard to imagine that, in the wonderful panels in which they occur, they mean no more than the symbolic appearance of a male or a female principle. Their force, their quality, their beauty stubbornly resist an explanation wherein Lascaux becomes a sequence of ox-horse formulas and Niaux a development of the formula ibex-bison-horse.

Every region, and almost every cave, is also supposed to have had its own private vocabulary of signs — here blazons, there ovals, in some places combs or roof shapes,

in others hands, rectangles, curves, and more or less open triangles. All these signs, varying from site to site, presumably designate a quite fundamental female principle. The same principle is expressed, but much more universally, by the realistic and symbolic representations of bison or bulls, representations that seem far more homogeneous, constant and communicable for all the regions and caves.

The Paleolithic religion, then, is assumed to have spoken in two widely divergent tongues to express its metaphysic of the opposition and the complementarity of the male and female principle. During the long dualistic meditation proposed to us by the new theorists, the artistic form of the signs apparently degenerated, while the art form which realistically represented the great mammals became surer, enriched with all the beauty of a living fauna. The representational language is majestic and universal; the language of signs is lackluster and without unity.

This is not the only paradox bravely taken in stride by the Young Turks of prehistory. An entire hunting civilization, they propose, gave visual expression in special localities to an abstract dogma by means of representations in which animals, their wounds, and the arrows surrounding these were reduced to symbols and male and female signs. In the representations of animals, one would expect the indications of the painting with regard to sex to be respected by the interpreters. It is true that precise clues are generally scarce, but they exist: at Lascaux, Altamira, and Pech-Merle, for example, the artist differentiated between bulls and cows. Secondary signs, such as horns and antlers, and even carriage, often permit an immediate identification as to sex. The more doubtful situation of the horse, when the male organ is not evident, is often decided by the size of the belly. But such specifications are not heeded by the new theorists. Sex is linked abstractly to the species, not to concrete individuals. Thus a large-bellied horse, formerly considered a "pregnant mare" is now merely a "well-fed horse" of male sign, and in the ox-horse theme the male animal, the horse, is balanced by either a cow or a bull, both in this instance being considered female. Other oddities, mere criticism of detail, could easily be cited.

The signs give trouble. The fact that all wounds are called female signs and all barbed lines male signs leads to difficulties. Granted that not all the animals are wounded, Leroi-Gourhan recognizes that fifteen percent of them unmistakably are. Hypotheses are often constructed with fewer examples. This irreducible percentage is worrisome, as is admitted in the following passage about the scene in the Shaft at Lascaux (Fig. 22): "There remain the signs. I once thought that the one at the feet of the man was his throwing stick and that the shaft with the bird's head was a throwing stick too, of the headless-animal type ... Now I am less sure. The first sign belongs to a very complete morphological series that goes from a realistic phallus to a stick with two lateral dots; it is therefore certainly a male sign. And it is perhaps no accident that the intestines coming out of the bison's wound take the form of concentric ovals. The identification assegai- phallus, wound-vulva, may here have found a variant expression. Does the male sign imply an identification: phallus-throwing stick? The means of comparison are too few to permit an answer, for the throwing stick is the object that shows the most variety in the animals represented. The sign with the bird is even more troublesome. Birds are rare in mural art as in 'art mobilier,' and their symbolic position is imprecise. The sign drawn here resembles a male sign in its lower portion: more can hardly be said."

These systems are conceivable, but to us obscure. Is not this vast interplay of paired signs reduced a little too theoretically to the contrast of male and female? Did the arrows stuck like banderillas in the animal's hide have the same meaning as those lines coming out of its nostrils, formerly associated with "the breath of life?" We do not know whether, in a religion supposedly intent on the contrast originating in the sexual sources of existence, life and death had their own signs or symbolic representations. Later, among other peoples, the horse was to play the role of guide between men and the underworld and to attend death as a messenger. We see him everywhere in the caves, and we do not know what symbolic value was attached to him.

To conclude this discussion of the successive interpretations of the mural paintings, it seems to us that not only does the percentage of wounded animals resist the most recent attempt at explanation, but that the works as a whole resist all theories. The great cave frescoes may be indeed a part of a grandiose mythology, with the fauna of the most important herbivores as its major reality, but the key to the world of the great hunt is lost. It depended on living relationships between men and the other populations then inhabiting the earth, wild beasts. We possess only pictures and signs; rather too conspicuously missing from this hunt is the hunter himself. Hypotheses are indispensable, and they must be pursued, but it is far too early to determine the metaphysical relationships these pictures harbor, although we have reached a point where we can study them as connected series. For the new theorists, the hunter has taken on the abstract aspect of a pre-Socratic philosopher, manipulating antagonistic and complementary principles. The interplay of the signs is paralleled by a descriptive art in which the images repeat themselves, always with individual variations. This psychological approach is eminently "primitive" in terms of the Lévi-Strauss definition: "... primitive mentality (la pensée sauvage) can be defined by a devouring symbolical ambition — of a kind never again experienced by mankind — and at the same time by a scrupulous attention directed entirely to the concrete ..."

No hypothesis, then, exhausts the complexity of the mural art. But attempts such as Leroi-Gourhan's to bring some order to it are necessary and worthwhile, even if, for the Martians that we are before the religion of the reindeer hunters, the frescoes must remain, if not dumb, then forever incapable of revealing to us with absolute certainty the meaning of the sanctuaries.

---

33 La Pasiega (Santander). Line drawings of horses. At left, back and hindquarters of a doe.

34 Las Monedas (Santander). Reindeer shown sideways near a fault.

---

Returning to the simpler task of examining the paintings as works of art, we shall try to define their stylistic qualities. We find ourselves dealing mainly with representations of animals, for if one excepts the friezes of hands, the "sorcerers," and large and small signs, the subject of Paleolithic painting is essentially the animal. We shall not dwell on the already sizable body of established facts. It has long been recognized, for example, that the technique of the frescoes demonstrates, especially for the middle and final periods, the presence of a solid traditional experience. The notion of schools existing at different periods of time has been abandoned for lack of proof, to give way to a concept of regional styles which conform to a general unity of inspiration but are distinguished from one another by a few peculiarities of execution. In Franco-Cantabrian art, three principal groupings are recognized: Périgord, the Pyrenees region, and northwestern Spain.

The question of how the forms were transmitted and perpetuated is difficult to clarify. The fact is that they cover in relatively homogeneous fashion the era of development — or part of the era of development — of a civilization that maintained a stable structure for thousands of years. The local differences appear negligible in view of this very broad and enduring unity, especially when one considers that there exist no rigorous copies and that no two groups of the known paintings reveal the same hand.

When an art truly respects its subject, spontaneity bursts forth everywhere. These pictures are never stereotyped. The adoption of well-established technical habits as well as the respect for subject distinguish this spontaneity from that of a child. Among the deep-rooted technical habits of the cave artists, one of the most characteristic is the positioning of the figure by means of the preliminary execution of the contour — a firm outline seemingly achieved with a single stroke. This first sketch of the silhouette, nearly always definitive, captures the distinctive posture of the species. Its almost unfailing quality places Paleolithic mural art in the forefront of animal painting of all time. The strong line from the head down the backbone of the figure especially is set forth with emphasis, while the line of the lower half may remain open or weaker.

The outline, sometimes incised, serves to delimit the color area when color is used. In general this outline consists of a brushstroke, often supple, sensitive, and forceful (Fig. 26.) Scored effects of hair or of woolly tufts may interrupt it to some degree, without breaking the rhythm. Sometimes the contours are executed not in line but with dots, which may be placed so close together as to appear almost continuous

(the hinds of Covalanas, Fig. 40.) They are occasionally produced by spurts of color shading off toward the edges (the rhinoceros of Lascaux.) This so-called blowing technique is sometimes used to give a misty aspect to manes, as in certain horses at Lascaux (Fig. 27.) It has been surmised that the color was blown through a tube, such as a hollow bone or a stem. Bones have been found with traces of color inside, which seems to testify to this use. With a few exceptions, the subject is treated in profile, although we shall see that certain details of the head and of the extremities undergo changes of perspective relative to the strict profile.

Before going further, let us point out one notable fact. In all of Paleolithic art, whether mural or portable, there is no indication of a groundline. The animal is a graphic entity that is not referred to a horizon or to any external landmark. Yet these beasts never give the impression of floating in a vacuum. They simply appear to follow a movement so true that the question of their stability and of the space around them does not arise. Lifelike and natural, they bespeak an immediate and total perception on the part of the artists, a perception sharpened, it has been suggested, by hunting. There is none of the abstract and documentary frontality of a zoological plate. The animals may gallop on the rock face without for a moment leaving the impression that nothing supports them, and here precisely lies the great achievement of Paleolithic mural art. These images are not meant to "be" animals, but to represent animals; they are works of art.

Further, we must remember that the paintings exist in caves where the lighting and varying size of the passages create conditions that are not those of painting or fresco realized in one plane. In this respect they may be compared to the sovereign figures which occupy overhangs or ceilings of architectural monuments, as do the "glories" and "majesties" of Byzantine art. We must consider the relationship of these works to the "architecture" of the cave.

The wall surface of the cave is utilized along the sides

35   Altamira (Santander). Polychrome hind on the ceiling. Before her, a little bison.

and overhead, but only partially and in such a way that the representations do not touch the ground. The caves are not adorned from one end to the other as a rule; an exception is Le Gabillou in the Dordogne, where the engravings, only a few of them enriched with painting, begin at the entrance and continue without interruption in the narrow defile through some twenty little chambers, separated by regularly spaced constrictions. In most of the caves, the paintings are located in corridors and chambers which are removed a certain distance from the outside entrance. Some isolated figurations are made less accessible by obstacles difficult to clear, such as pools, pits, and clefts. The decorated area, whose length varies according to the configuration of the cave, consists of a sequence of ornamented panels separated by empty ones. In the central portions, the decorations are often crowded together and superposed, even though many nearby blank spaces were available. Much has been made of the ingenuity displayed in the utilization of irregularities of the rock face, such as the adaption of the bison portrayed on the contours of the existing rocky humps of the ceiling of Altamira. Such examples are numerous without constituting the rule. Most of the figures are actually placed on surfaces, lateral or curving overhead, that are not particularly evocative in form. The use of special suggestive conformations, however, often show humor. At Altamira, for example, some excrescences resembling grotesque muzzles have been enlivened by the addition of eyes. Similarly at Niaux, a hollow more or less in the shape of a stag's head has been crowned with painted antlers — a rudimentary application, if you will, of the idea of supplementing the "ready-made" and of the equivalence of positive mass and negative hollow space.

Certain topographical features of the caves seem to have arrested the attention of the artists for reasons difficult to determine. Along some of the fissures animals are depicted in unaccustomed positions: vertical at Las Monedas (Fig. 34), upside down at the end of the Axial Gallery at Lascaux (Fig. 11), where the corridor is abruptly blocked and seems to slope toward the depths. The second example suggests a hunting practice after the pattern evoked at Solutré by the remains of horses found at the foot of a cliff: the hunted animal presumably fell into the void. But this explanation does not hold for the first example, in which the attitude is peaceful. It is possible — but entirely unproven — that these figurations near faults, chimneys, or sinkholes, where the horse is often present, point to a symbolic relation with the hidden portions of the cave. The placement of figures in relation to fissures and passageways must be further analyzed.

The utilization of natural features such as rocky ledges for backbone lines and stalagmitic formations for legs by no means calls into question the existence of an excellent repertory of painting techniques. The materials used are fairly well known. A good many stone palettes and pestles and mortars for grinding color have been discovered (Laugerie-Basse, La Madeleine), as well as evidence of the calcination or powdering of ochers. Bits of ocher and manganese have sometimes been found near pieces showing traces of regular rubbing. Ocher crayons have been preserved in certain caves, as have stone lamps. To be sure, the lamps that have come down to us are perhaps not the ones that lighted the artists: they might have been left by visitors. Sources of light of this sort were, however, indispensable for work in portions of the cave deprived of daylight. In the same way, scaffolding was necessary to reach the upper parts of the decoration, and the location of the timbers has been ascertained. Thus, even on a technical plane, there was nothing of haphazard personal improvisation about the painting. On the contrary: the surviving traces of a very efficient material organization make one aware that, although the art work itself may have been produced by individuals, a sizable group must have supported and planned the practical steps preliminary to its creation.

Blacks and reds — these last more or less violet or brown — are the markedly dominant colors in Western Paleolithic painting. Some yellows are also present, but whites, blues, and greens are lacking. The effects of white — very striking at Lascaux, for example — are due to a film of light calcite left unpainted. The pigments that have come down to us are all of mineral origin. Iron oxides ($Fe^2O^3$, $Fe^3O^4$), for the reds and browns, and manganese dioxide ($MnO^2$), for the blacks, were those most used. The minerals were either cut into crayons or ground and amalgamated with an unknown binding material — probably an aminal fat or water.

The design was sometimes produced by finger tracing, either with a dry finger on walls covered with a thin layer of soft clay, or by dipping one or several fingers in semiliquid clay, which left trails of reddish lines (rudimentary contours of animals and meandering lines known as "macaronis.") The hand also served as a pattern when the blowing technique was applied to make friezes of "negative" hands, outlined in black or red by color projected around them. But only the use of a brush can account for the precision and sensitivity of the line in the fine representations. No doubt, like all brushes in the world, the one used by Paleolithic artists incorporated a tuft of animal bristles. One may also assume the use of vegetable fibers and swabs. Whatever the materials used, their quality has been proven not only by the effect of the works, but by their survival to the present time.

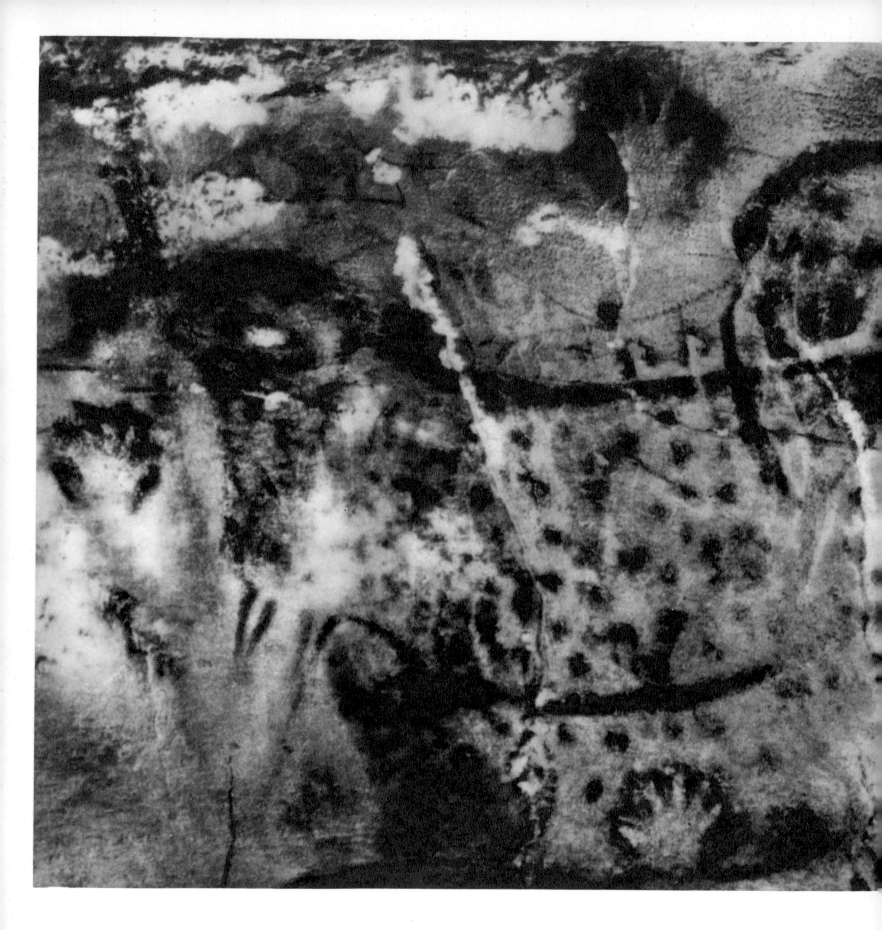

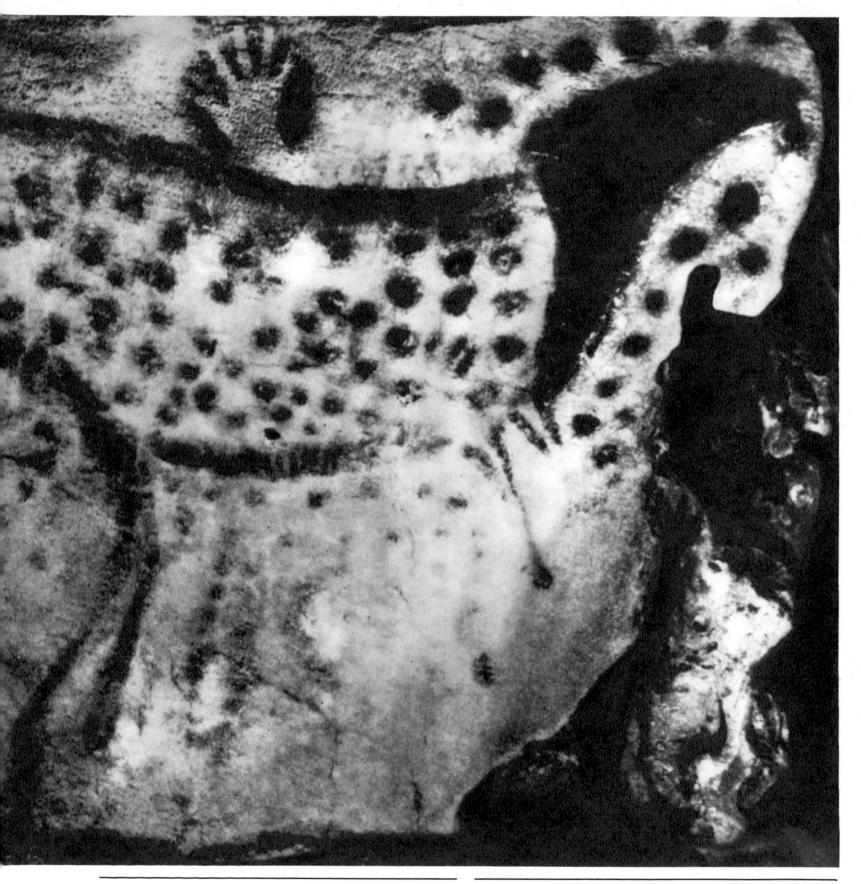

36 Pech-Merle (Lot). Great panel of the "polka-dotted" horses with negative hands circled in black. There is a large fish (pike) above the right-hand horse, which has an extremely small head and a red circle on its breast. A brilliant plastic composition emerges through the equilibrium of black and red dots on the horses and in the background.

The stylistic method of dating Paleolithic art is based on an analysis of the evolution of the forms. For Breuil this evolution comprises two cycles: the Aurignacio-Perigordian and the Solutreo-Magdalenian. In each, the figurations appear in an order of increasing complexity, attain a golden age, and degenerate.

The first cycle includes: hands circled in color, "the very barbaric large red animals of Altamira" painted in wide red bands or in solid color, linear drawings, broad "dribbling" tracings, flat washes, bichrome representations, and the "gigantic" figures (Lascaux) in which "twisted perspective" was gradually, corrected.

In the second cycle, the Solutreo-Magdalenian, the same phases repeat themselves in approximately the same order. The Solutrean period, which is nearly sterile in the realm of mural art, contributed little or nothing. The early Magdalenians produced black line drawings before their representations were enriched with modeling and polychromy and attained a culminating point in certain works at Altamira and Font-de-Gaume. The abandonment of naturalism in favor of schematization brought with it a decline, noticeable in the small red tracings at Niaux, for example — after this came the abstraction of Azilian signs.

Mural art then underwent two creative surges, according to this classification to which Breuil devoted his long study of decorated caves and his exceptional intuition. He applied three criteria in the reconstruction of this stylistic evolution. First, he assumed that the most rudimentary figurations are the oldest, at least in each of the cycles. From this point of view, modeling and polychromy signify excellence of workmanship and maturity, even though the black line tracings "of a fine style" (large bovids at Lascaux; Figs. 14, 15) likewise testify to an accomplished artistry. This criterion, then, is one of complexity and quality. The second depends on the deciphering of superpositions, where, of course, the most recent representations cover the others. But it appears that Breuil considered a third criterion, that of "twisted perspective," by far the most important, allowing it to play an altogether decisive role not only in dating the figures but in establishing the developmental span of the styles. The attribution of various phases of the decoration of Lascaux, for example, to far earlier periods (Aurignacian) than are accepted today is in great part due to Breuil's conviction that twisted perspective is evidence of archaism. It is surprising that such a characteristic element of representation has aroused far more interest as a means of dating than as a pictorial device per se.

What is "twisted perspective?"

It must be emphasized, first of all, that Breuil's expression, which has become classic, designates only approximately a graphic device that is very widespread in prehistoric art. It is a way of enhancing the descriptive and plastic value of

---

38  *La Pasiega (Santander), Gallery C. Arabesque of a bison consisting entirely of curves. There is a counterpart at Rouffignac (Dordogne).*

---

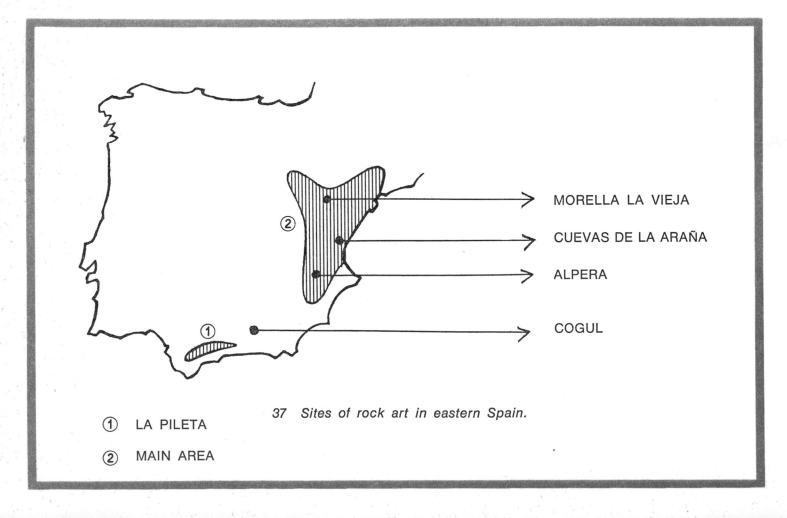

37  *Sites of rock art in eastern Spain.*

① LA PILETA

② MAIN AREA

MORELLA LA VIEJA

CUEVAS DE LA ARAÑA

ALPERA

COGUL

the representation through changes in the viewing angle. Thus in the figuration of a bull (Fig. 10) or a bison presented in profile, the horns and hoofs are drawn fullface or in three-quarters view. The perspective is not "twisted" actually, but, for certain details which are always the same, the drawing undergoes a sudden change of plane, and portions of the animal normally hidden in frontal view are rotated forward and often projected with a special insistence. The changes of plane, which affect only peripheral details of the silhouette, never give an impression of torsion. Quite on the contrary, they add a kind of density, of relief, to the figure. In an art which has no shadows, they felicitously suggest depth. They enrich the rendering of volume in painting with some very appealing poetic touches: fine lyre-shaped horns, stag's antlers gracefully outspread (Fig. 24), etc. But, most important, the new spatial references often contribute markedly to animating and diversifying the contour of the animal without, however, warping, deforming, or "twisting" it. The picture remains an entity with no break in rhythm. This is particularly true of the original in the cave. The fact is that the accent placed by the altered perspective on antlers, horns, or feet — an accent that complements the modeling and takes its cue from the topography of the rock to help balance the central mass — largely eludes reproduction in the rigorous plane of a tracing or a photograph, where disproportions are revealed that are often imperceptible on the rock.

The use of such devices, which, like the effects which show modeling by hatching or shading, are strictly graphic conventions, shows the stylistic freedom inherent in the alleged naturalism of the mural art. It proves that Paleolithic painting is neither a visual realism, since in reality animals can turn their heads but not their horns only, nor an intellectual realism, since it alters perception of the animal only in subtle and perhaps symbolic fashion. One might even say that it provides an extra degree of specific visual exactitude. Note that the mural art forgoes representation by transparency, that it does not depict internal features. It captures a noble, lifelike image of the animal, composed of what is best in its external aspect.

Twisted perspective is first and foremost a device for improving the presentation and adding a somewhat pointed description of favored details. Yet it is possible that the choice of details was not primarily determined by aesthetics; this is suggested by the more complex changes of plane common in prehistoric engraving which, as often as not, seem of mediocre artistic effect to us.

The stylistic criteria employed for dating the painting have the merit, above all, of making us analyze its artistic qualities — whether, as with Breuil, the emphasis is on twisted perspective or whether, in accordance with more recent points of view, it is on the proportions allotted to the various parts of the body (the undersized head and members in massive silhouettes like those of the horses of Lascaux, for example, are supposed to be characteristic of "Period III"), on the sinuousness of the cervico-dorsal curve, or

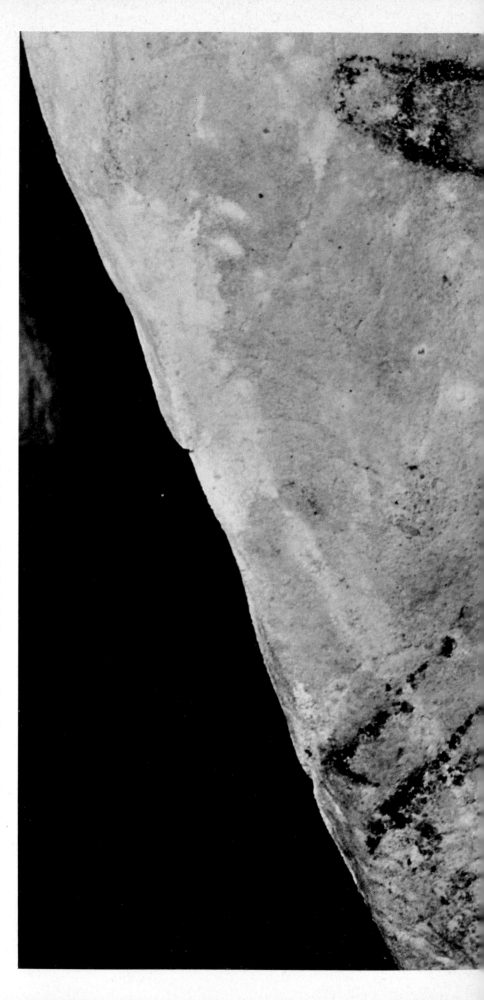

39 *Las Monedas (Santander). Horse along a fault. This is a stiff, hesitant drawing that has been reworked.*

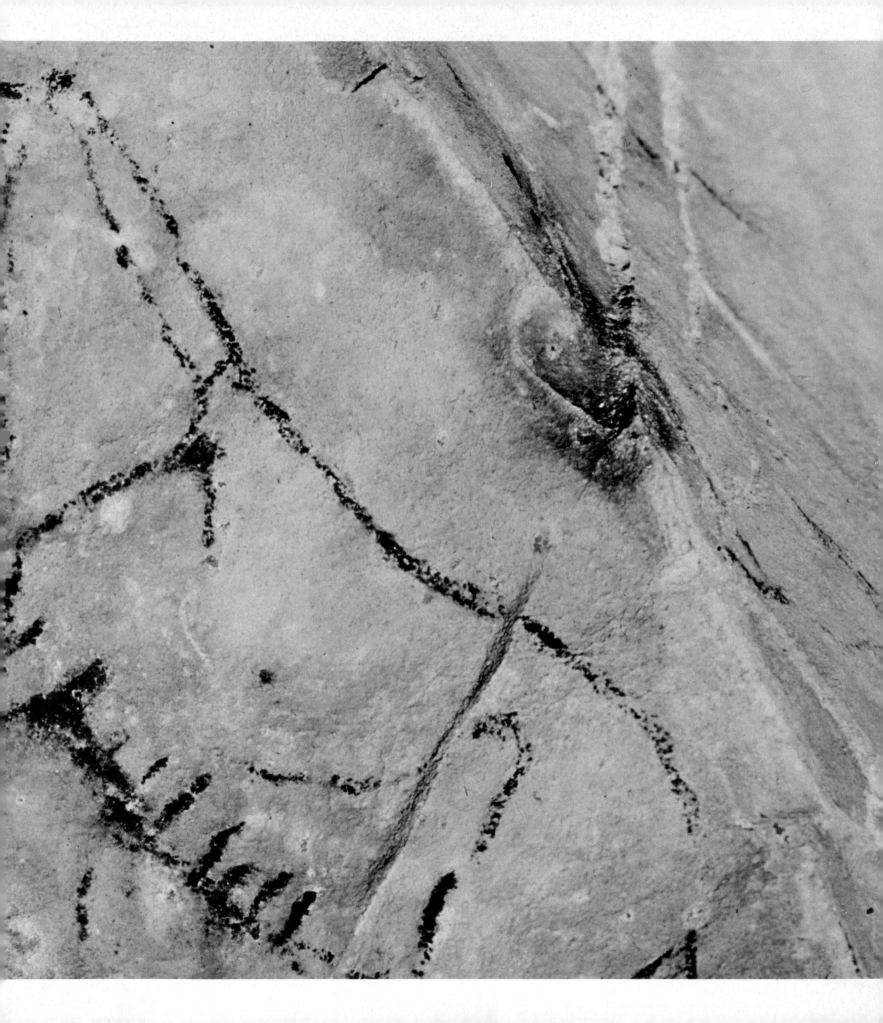

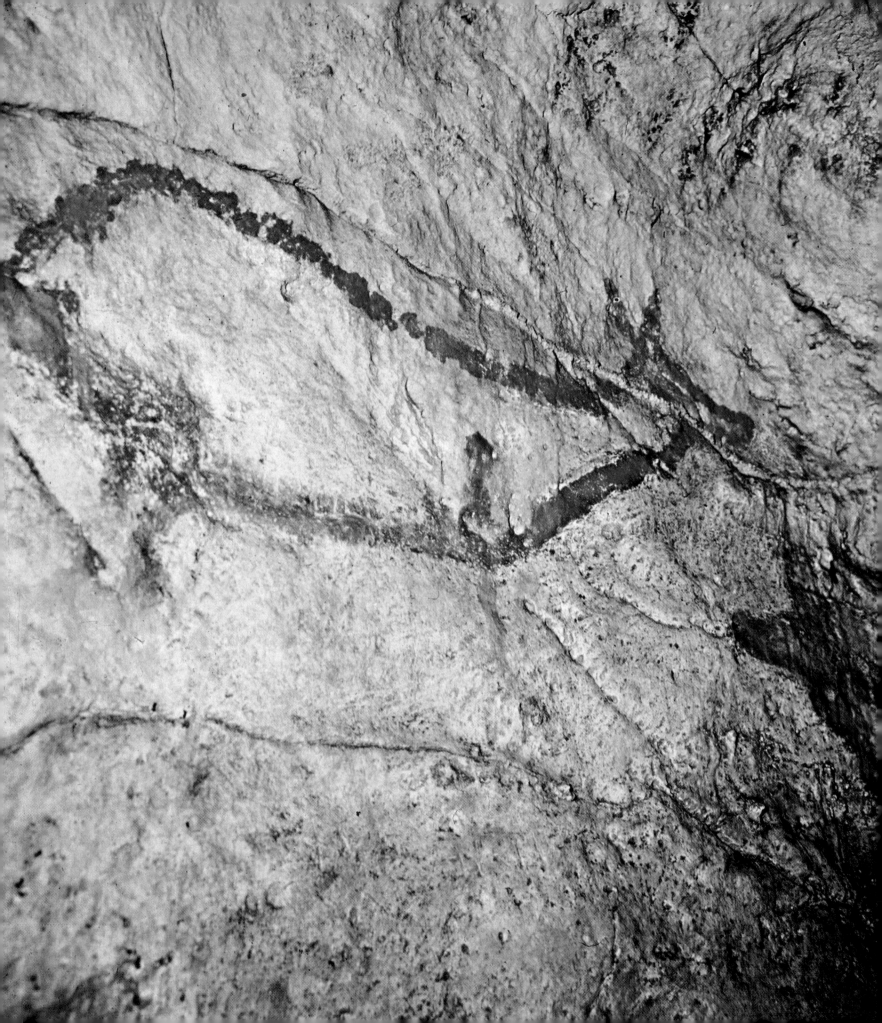

on the distribution of the color or hatching, limited by curves descending toward the legs and belly. Unfortunately, the mural painting almost completely eludes the only truly accurate criterion of prehistoric dating: stratigraphy.

In a few rare cases the mural decorations are covered by archaeological strata, and information can be gained by the normal procedures of prehistoric dating: examination of the tool fragments, of pollen, use of radiocarbon, etc. We are especially fortunate when fragments of the actual painting have dropped from the walls into ancient and datable strata, as at Lascaux. But most often, one must rely on comparisons with objects of "art mobilier" which have been dated, or with references to archaeological deposits, where these exist, at the entrance of the cave. In other words, reliable clues are few and far between.

For Leroi-Gourhan, who rejects Breuil's two cycles and recognizes but a single development, a "remarkably progressive general unfolding," the chronology of styles must be based on the rare certainties of "the critical inventory of dated documents." In point of fact, for the painting, this inventory offers only a very insufficient, brief list of relatively late works, and even for a "provisional" classification there is no getting away from Breuil's old criteria, which Leroi-Gourhan does not greatly modify.

The difference between the two chronologies is one of results rather than principles, and it derives from the hypothesis of a "remarkably progressive general unfolding" as opposed to the idea of the two cycles. Let us point out that it is not surprising for an evolution to appear progressive if the works have been classified in order of richness; if the mature painting is placed in shorter and more recent periods, the idea of two cycles becomes untenable. On the other hand, this idea can present no objection if the painting is taken to have begun in the Aurignacian. Two or more parallel developmental curves are entirely conceivable in over twenty thousand years. Such awakenings and returns are not unknown in the history of art.

In Leroi-Gourhan's chronology the development of the painting is more compressed and more recent. The rudimentary figures are relegated to "archaic" Styles I and II. The others belong to Style III and the first phase of Style IV. The second phase of Style IV saw the decoration of subterranean sanctuaries give way to carving on plaquettes and other objects. To Style III belong Lascaux, Pech-Merle, and certain panels of Altamira, Font-de-Gaume, La Mouthe, Gargas, etc. To early Style IV belong Rouffignac, Niaux, the great ceiling of Altamira, and most of the figures of Font-de-Gaume, Les Trois-Frères, Marsoulas, etc. All in all, according to this chronology, it took some ten thousand years for the painting of the great sanctuaries to evolve; production was intense during the early Magdalenian (I and II), which coincides more or less with Style III, and during

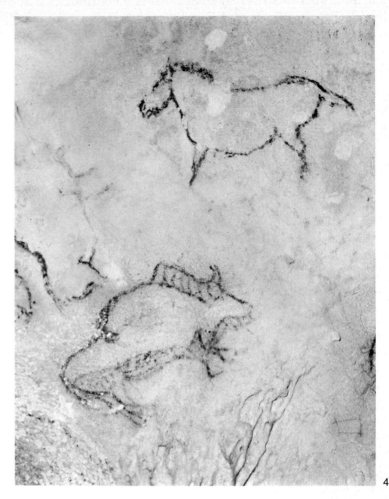

41

the middle Magdalenian (III-IV), the period of Early Style IV. In absolute chronology, the fifteenth millennium B.C. was at the core of the phenomenon. To be sure, paintings already existed before the twentieth millennium: animals traced with clay at La Baume-Latrone, archaic figures at El Castillo, for example. Leroi-Gourhan prudently holds that the lack of archaeological context, as well as the worn state of the figurations and their scarcity, prevents determination of their stylistic position. There have been some irreparable losses. We need only cite the case of the Pair-non-Pair cave, where Daleau in 1899, with the help of a vineyard pump, had the walls "washed down with a great stream of water;" now these walls retain only insignificant traces of black painting.

One fact remains certain: the sequence of styles established by Breuil in a concrete and complicated fashion, and outlined in a more abstract and simpler manner by Leroi-Gourhan, is, for the painting, extremely difficult to apply. The assumption that the frescoes were created in a more recent period of shorter duration does not really help us. The comparisons to "art mobilier" become more abundant then, but nothing proves that these are chronologically decisive. Between the great frescoes and the decoration of

40 *Covalanas (Santander). A not ungraceful hind outlined in red dots placed close together.*

41 *Santimamiñe (Vizcaya). Horse and bison of the central panel. There is ease in the treatment of the horse and good observation in the bison's spring coat.*

objects there may be a gap on the order of that separating Byzantine painting from a holy-water basin sold at Lourdes.

The composition, when it is clear to us, does not seem to bear an obvious relation to the thematic organization that Leroi-Gourhan and others have attributed to the mural art. The great ensembles are apparently not composed aesthetically to bring out the essential confrontation of the male and female principles. It is true that the order underlying the associations of animals and of opposite and complementary signs may have been deliberately concealed for religious reasons. But are we not here entering on the forbidden game of explanations in terms of motives? Be that as it may, on the vault of the Axial Gallery of Lascaux the brilliant juxtaposition of delicate bovine heads (Fig. 11) is not very clear from the point of view of a theory of sacred content. It is easy, of course, to find horses to re-establish the antithetical themes — there are many horses in the gallery — but the thematic and compositional structures do not coincide. Differences, often important ones, in technique, scale, color, rhythm — in fact, date — produce figures frequently intermingled, going in every direction, between which there is no necessary connection. If a primordial iconographic order directly expressed in precise sequence had existed, it would have been surprising for it to escape the attention of the observers who preceded Mme. Laming-Emperaire and Leroi-Gourhan. What all of the earlier students noted instead were two facts: the more or less pervasive disorder of the figurations and, at times, certain felicitous groupings.

A few scenes which are not very remarkable as works of art have a special interest because of their mysterious narrative character, especially those with human or semi-human personages (the scene in the Shaft at Lascaux, the "sorcerers" of Les Trois-Frères, Pech-Merle, and Cougnac). With these exceptions the special effects of the notable works of prehistoric art are aesthetic ones. The paintings involving animal figures are spectacular evidence of the artists' creative power, exercised now with authority as it magnifies the vigorous presence of the big bulls of Lascaux and translates into heavy serried rhythms the might of the massed bison on the ceiling of Altamira, now with truly poetic feeling as it captures the grace of a row of stags' heads or the amusing parade of "ponies" at Lascaux.

In several cases the quality of a scene from the animal world seems to have arrested the artists' attention: two bison back to back suddenly separate, carried forward by an irresistible impetus (Lascaux; Fig. 23); or silhouettes of mammoths overlap in a hazy composition whose curves evoke, in a sort of distant landscape, the passage — which must have been an impressive one — of the majestic herds of huge pachyderms (Pech-Merle). But if interest in the beauty or picturesqueness of the subject is sometimes unmistakable and finds admirable visual expression — in the delicate rendering of muzzles, in speaking poses, and spirited movements — it nonetheless remains true that most of the mural painting does not convey an attitude of gratuitous enjoyment. The animal figures tend to take on a heraldic aspect and can hardly be regarded as exercises on a theme or samples of spontaneously moved description.

The existence of graphic conventions shows that a symbolic system underlies the figures, whose naturalistic character should not mislead us. In some of its aspects the mural painting could be compared with certain archaic tapestries: the panel of dotted horses with hands at Pech-Merle, for example (Fig. 36), with the frank monumentality and free elegance of an early hanging. The composition harmoniously marries animal representation — here conventional to the point of being restricted to an arabesque close to stylization — and the interplay of abstract signs (the rows of dots) and symbols (hands, the red circle, and perhaps the fish). In other ensembles (Niaux, Le Portel, Santimamiñe, etc.) only the utilization of the space to be decorated is still clear to us, and, once this observation is made, the disposition of the animals, the way they intersect, their numbers, and their respective proportions are inexplicable.

The working hypothesis proposed by Leroi-Gourhan is for the time being the only systematic attempt at investigation offering an analytic breakdown of the figures. From an aesthetic point of view, an obvious objection to this hypothesis is that it accounts for the sequence of panels in a mechanical fashion. His extensive survey of the caves is, naturally enough, almost exclusively an effort to find in each a replica of the theoretically ideal sanctuary. Others had defined Lascaux only in terms of "a fondness for horses;" there was doubtless a need to seek a more meaningful explanation. Leroi-Gourhan defines the Great Hall at Lascaux, by reaction and by principle, as an ensemble composed of two complementary groups: "large red bulls and bovids accompanied by male signs on the right, cow and horses accompanied by female signs on the left," and the Axial Gallery "is composed of . . . two alternating groups (cow-rectangle-horses and bull-barbed sign-cow), framed by stags, with complementary ibexes and an isolated bison-horse composition." It is plain that a schematic interpretation is no more satisfying than pure lyricism. Unfortunately the mechanical and the aesthetic points of view cannot even complement each other: neither to our feelings nor to our minds is the mural art fully accessible thus far. It is in this authentic resistance to simplification that the arresting originality of its sanctuaries resides; we should not, for all that, give up the attempt at definition.

The description of the summits of Paleolithic mural art, Breuil's "six giants" — Altamira, Font-de-Gaume, Les Combarelles, Lascaux, Les Trois-Frères, and Niaux — and of the other decorated caves, is not feasible within the scope of this book. Lascaux, the star, has been the subject of innumerable publications. Altamira deservedly shares the limelight. The other Perigordian ensembles are more problematic, because they are less legible, because they are

42 *Las Chimeneas (Santander). Hind in firm black line. The silhouette is elegant but the legs are stiff and the extremities disregarded.*

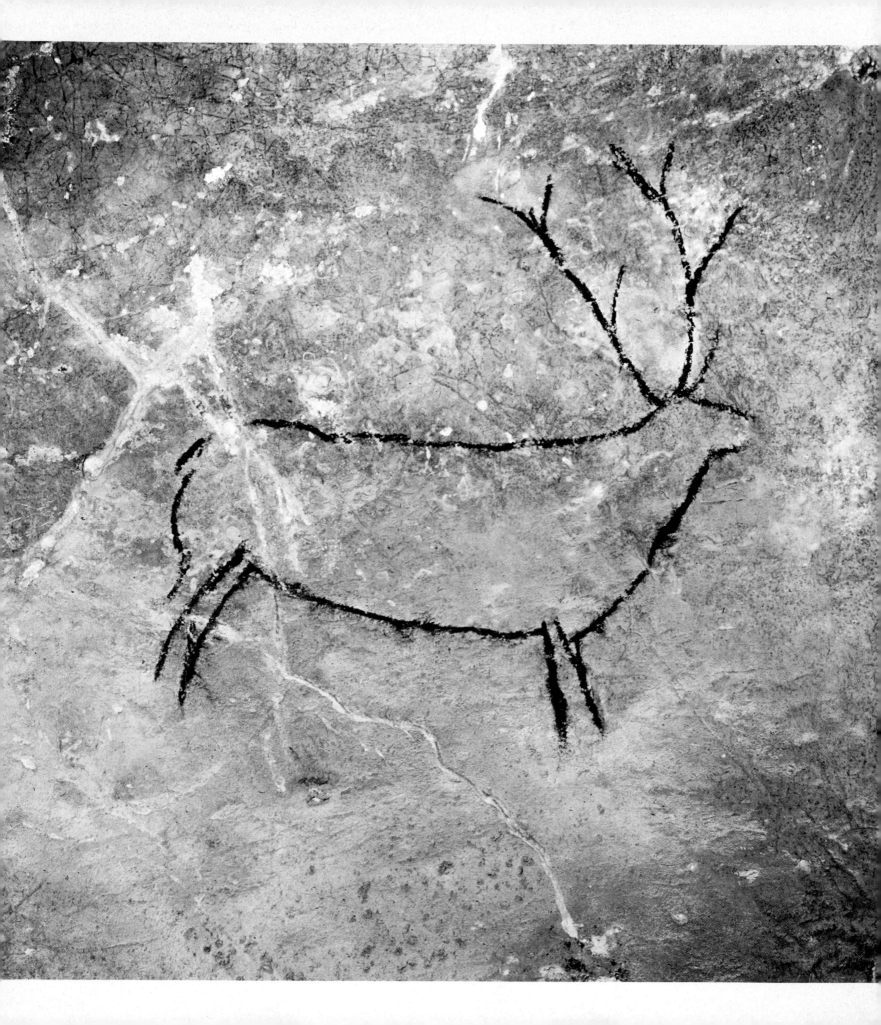

43

## ROCK PAINTING AND CARVING: MEDITERRANEAN, LEVANTINE, AFRICAN AND AUSTRALIAN

### The Mediterranean Province

The prehistoric mural painting of western Europe is definitely centered in southwestern France and northwestern Spain. Scattered works have been found, however, in a wide arc passing from Sicily and Andalusia through the lower Rhone valley, the French provinces of Ardèche and Gard. Because of the sparseness of the deposits and the often poor conditions for observation, it has been difficult to date and place these works. The present tendency, influenced by the works of Paolo Graziosi, is to see in them a "Mediterranean province," differing in style from the great Franco-Cantabrian centers, but apparently following the same cultural patterns.

Comparing the Franco-Cantabrian and Mediterranean styles, Graziosi writes: "It is the same spirit, the same superposition of figures, the same somewhat chaotic disposition of animals, the same sureness of line, with the execution of a profile traced in one stroke and without hesitation." The essential stylistic difference lies in the treatment of the horns of the bovids: in the Mediterranean drawings the horns are parallel in their lower and middle portions, with a gap at the base; they open out slightly before the ends.

The southern Italian sites include the Romanelli cave (Castro Marino, province of Otranto), the Sicilian caves of

sometimes much altered, like Font-de-Gaume, or because, like Rouffignac, they present panels that are too widely dispersed. We shall simply note the interest of the too often neglected Pyrenean region, where extremely spacious caves, sometimes as high as cathedrals, afford pathways often bored in marble and broken by lakes or sand hills. The Spanish region should not be limited in the minds of visitors to Altamira.

Prehistoric painting of the Upper Paleolithic cannot be separated from a long experience of the subterranean world. It was born in most instances, and always in the great classic sanctuaries, in the entrails of the earth, where it found its meaning. It was possibly contemporaneous with other forms of outdoor art besides those of the open-air sites. We know that color covered sculpture; it may also have been used in bodily ornament, in the decoration of hides, etc. But we must consider that for us Paleolithic painting consists primarily of rich and recurrent ensembles in the darkness of caves: only on the borders of silence and night may these extraordinary vestiges regain their voices and one day, perhaps, attain a little clarity for us.

43 *Santimamiñe (Vizcaya). Two bison in vertical position next to a fault.*

44 *Distribution of rock art in Africa.*

45 *Site in Nubia.*

46 *Nubia. Engraved antelopes.*

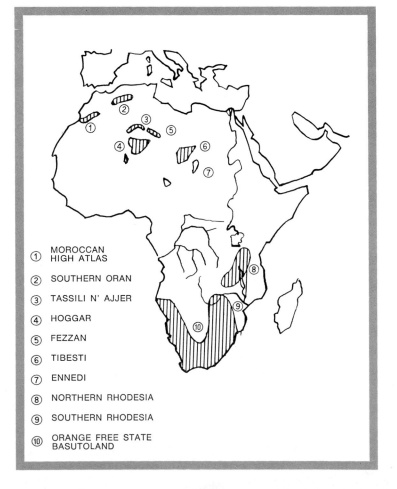

① MOROCCAN HIGH ATLAS

② SOUTHERN ORAN

③ TASSILI N' AJJER

④ HOGGAR

⑤ FEZZAN

⑥ TIBESTI

⑦ ENNEDI

⑧ NORTHERN RHODESIA

⑨ SOUTHERN RHODESIA

⑩ ORANGE FREE STATE BASUTOLAND

46

Monte Pellegrino (Addaura, Nicemi), and the cave on Levanzo, a little island of the Egadi archipelago about nine miles from the western tip of Sicily. The works found in these Italian sites are engraved. A somewhat doubtful clayey coating indicates that they may once have been painted, but it is the style and subject matter which relate them directly to the mural painting. One finds disguised men with birds' heads, elegant bovids as at Lascaux, the same fauna as in France and Spain, though less complete, and very similar signs.

The French Mediterranean sites include Ebbou, Le Colombier, Oullins, and Le Figuier in the province of Ardèche; Chabot, Bayol, La Baume-Latrone in the province of Gard; Sallèles-Cabardès in the province of Aude; and Aldène in the province of Hérault. The works are poor in painting — engravings are more numerous — and difficult to classify. The bear's head painted in red ocher at Aldène is very rudimentary. Finger tracings on clay and soft contours drawn with ocher are common to the region; examples are particularly abundant in the cave of La Baume-Latrone, with its rhythmical mammoths and its serpentiforms. This has suggested a connection with the oldest works of the Andalusian group, but such contours also exist in the Franco-Cantabrian region at Gargas. On the other hand,

in the linear figures the drawing is firm and very rigid. The animals, whose limbs show neither detailed extremities nor points, have, as Breuil has commented, only "one leg per pair." They seem supported by two triangles whose sides are sometimes prolonged beyond their intersection; thus one might also see the legs as crossed. These representations have been related to those of southern Italy, which are less angular however.

As one considers the southern Andalusian group, of which La Pileta is the center and which includes Ardales, Las Palomas, and La Cala, one realizes that it contains Franco-Cantabrian stylistic elements mingled with those just described for the Mediterranean caves. Despite the often rudimentary state of the works, it seems reasonable to infer that the artists in these areas maintained some com-

47  Liveliness and variety in African rock art.

(a)  Tassili. "The Martian."

(b)  High Atlas. Elegant bovid's head.

(c)  High Atlas. Chariot drawn at a "flying gallop."

(d)  Fif Gaguine. Bovid with characteristic long legs and markings on the flank.

(e)  Personage brandishing a weapon; ax at right.

(f)  Talat n' Isk, High Atlas. Large disk, engraved, pecked, and polished.

(g)  Oukaimeden (Morocco). Daggers and halberd.

(h)  Talat n' Isk. Human representation.

(i)  Tizi n' Tirlist, High Atlas. Engravings.

(j)  Oukaimeden. Female figures.

(k)  Tassili. Human figures and bovid with markings.

(l)  Tizi n' Tirlist. Bold stylized human representations.

f

g

h

i

j

k

l

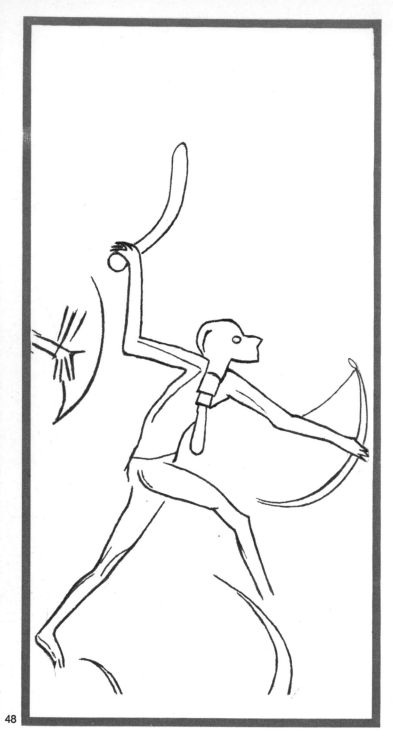

48

## The Spanish Levant

Rock painting in the "Spanish Levant" — between the Pyrenees and the province of Murcia — constitutes a fairly homogeneous group of particularly lively works. Even for Breuil, who often stressed its bonds with Franco-Cantabrian mural art, it is a group apart which he did not introduce into his *Four Hundred Centuries of Cave Art*. With the Levantine painting we enter a world whose secular character contrasts with the heavily charged symbolic feeling of the previous production. The differences begin with the location of the decorated panels: they are under rock shelters or at the foot of cliffs and not in caves. Discovery began in 1903 in the province of Teruel. Cogul, with its "dance of women" painted in red and black, Minadeta, then La Vieja, were successively studied until 1914; the stations currently known number about fifty. The figurations are generally small and mingle men and animals. The movement is of surprising vitality. In the human representations it is rendered by wide gestures of the arms and a broad spread of the legs. Arrows fly, animals flee at top speed. There are picturesque processions, furious battles with filiform, very excited warriors. Many archers, honey gatherers — in short, narratives — are offered us. It is an art without masterpieces, where much is mediocre but life abounds.

It was easy to interpret this art as merely a record of the daily occupations of peoples who, though they were still hunters, practiced gathering, and whose apparel and equipment it makes known to us. Yet Almagro has noted that the works, which occasionally carry ancient traces of repainting or alteration, occupy niches or sites maintained, to his mind, with a diligence and respect that denote sacred places. From this point of view the nature of the works is not very clear, and it raises two questions: that of their connection with Franco-Cantabrian art and that of date.

The first is inseparable from the evolution of this art. Indeed, though the art of eastern Spain takes its departure from animal representation, perhaps derived from Franco-Cantabrian art, it is considerably removed from that art in a treatment that excludes modeling and tends to simple flat cutout effects. The absence of a sustained system of signs, the growing importance of scenes with human personages that become more and more schematized, as well as the presence of iconographically new zoological species such as the dog and the spider, constitute important differences. We may fairly confidently assign a later date to the Levantine art. The archaic fauna of the earlier, colder climate are entirely missing; the industry, moreover, seems to be Mesolithic and even Neolithic. A late date is also suggested by the presence of domestic animals in the drawings.

Various hypotheses have been advanced in an attempt to place the art of eastern Spain. Almagro (1954), noting the isolation of the sites in a mountainous hinterland, concludes that it is a survival from an earlier culture. These paintings — postglacial, to judge from the animals represented — were created, he suggests, by "Mesolithic hunters who long preserved their belated way of life in the desolate mountains of eastern Spain." The artistic tradition they embodied might thus have lasted even after the establishment of the

munication; these supposed connections have been extended as far as North Africa by certain authors.

Still poorly dated, the Mediterranean developments in mural art tell us little about the end of the great painting of the Paleolithic sanctuaries. We know that by about 9000 B.C. the reindeer had left forever the territories of Spain and southern France, and the first flare of civilization in the West had died away. The mural art had lost its monumental breadth well before this time.

Neolithic era at the end of the fourth millennium B.C., without severing its stylistic bonds with the Paleolithic: "One cannot deny the existence of points of contact and parallels which make likely a transmission of Paleolithic rock art by Perigordians, that is, by migrants from France, carriers of a civilization that spread into Spain, where the foundations of the later Paleolithic and Mesolithic civilizations were laid by them. Their blood still flows in Spanish veins." But why did similar groups not survive in other, equally mountainous regions? Other authors have considered influences coming from the North African Capsian culture. Still others deduce, from the bell shapes assumed by certain garments, the possibility of influences from Minoan Crete.

In fact, the links of Levantine art with Franco-Cantabrian styles seem limited, and with many reservations, to animal representations. A more interesting unanswered question concerns its connections with Africa. That there are connections is beyond doubt; microliths of African type appear among the tools of eastern Spain; the triple-curved "Asiatic" bow is represented on both sides of the Mediterranean; and

---

48  *A genre scene: not "prehistoric" in character. There are innumerable examples in Africa.*

49  *Paintings on hide by American Plains Indians.*

---

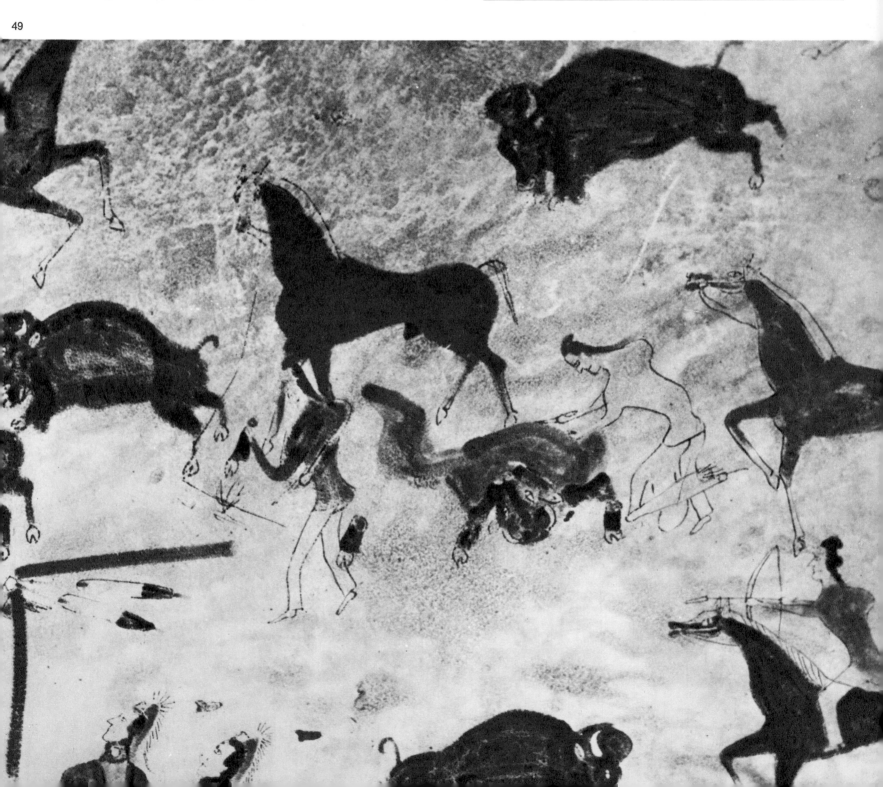

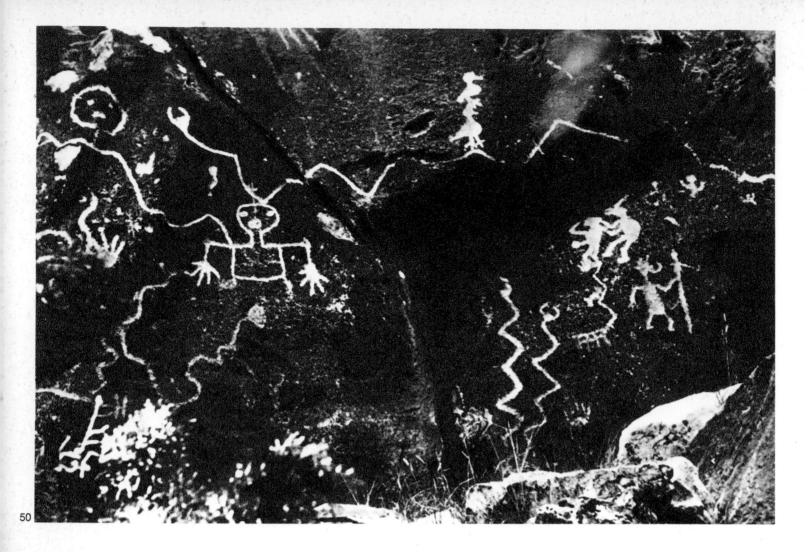

50

similarities stressed by K. J. Narr and recognized by all writers undeniably exist between the decorated panels of eastern Spain and those of the Tassili, for example. But even though a certain unity is perceptible in that immense number of documents so widely scattered through time and space, it is surely premature to speak of a vast "Eurafrican hunting civilization." Indeed the essential problem, that of the direction in which the exchanges took place, Europe to Africa or Africa to Europe, has not been resolved, and the chronology of African rock art, more than any other, remains in many respects purely hypothetical.

## Southern Africa

Africa, immense storehouse of an ageless past, is incomparably rich in rock art (Figs. 28, 44-48). The examples that have been recorded — suffice it to mention Breuil's surveys in South Africa and Brenan's and Lhote's in the Tassili — are innumerable. They go into the thousands. This vast inventory continues to grow at sight — we need only mention the recent discoveries in the Ennedi and Nubia —

yet without altogether clarifying the sequence of civilizations on this still largely enigmatic continent. For prehistoric art, Africa does not play the originating role attributed to it by anthropologists who consider it the "cradle of humanity." It appears that the land that probably witnessed the first experiments of *homo faber* and the development of our prehominid ancestors did not become a region of artistic activity until rather late — at least in the light of currently known documents.

The African chronology of cultures does not, on the basis of the tools, coincide with the European. The chronology of the works of art, which in general rests only on rather vague similarities of style (the earliest styles, for example, are supposed to have a "Paleolithic ambience"), suffers almost everywhere from the absence of excavated pieces that would permit rigorous dating of the paintings and engravings. Often situated in the open, the works can hardly ever, as is sometimes the case with Franco-Cantabrian art, be checked against a conclusive stratigraphic filling, and along the trails the tools have almost always been scattered.

50-51 *American Indian rock engravings, showing rather elementary schematism and abstract symbolism.*

Parallels, which vary depending on the author, have been established between the artistic developments in Europe and Africa. But Africa offers at least one original feature: the extraordinary persistence of rock art, which has lasted in a form that concerns ethnology until our day while it disappeared in Europe a few thousand years ago. It is paradoxical that the Neolithic revolution, which marked the end of the great prehistoric painting of the West, should in

Africa have fostered an artistic production by pastoral peoples — a long-lived and brilliant surge of rock painting.

Here we must recall Breuil's surprise over the discovery of the famous "White Lady" of the Brandberg, in southwest Africa. It was entirely unexpected to find a human representation that was neither of the Bushman nor of the Bantu race but that seemed to belong to the white race and thus posed problems of migration in relation to Egypt and the eastern Mediterranean. It was also astonishing to come upon a noble and somewhat hieratic art, a consummate art of polychrome fresco with fine white highlights. These things could not fail to impress the tireless visitor of Western caves. For this young girl — who probably is a man — carrying a bow and a flower, who "strides, young, beautiful, and lithe, with an almost airy gait," Breuil has proposed a date today thought too ancient, but his classification of southern African works remains valid. He distinguishes the panels engraved on basaltic rock of the high plateau, and painted on the shelters under sandstone rocks around it, from the panels adorning the granitic caves of southwest Africa, the northern Transvaal, and Southern Rhodesia. For him this art began in the Middle Stone Age, and its most ancient manifestations "would thus join in time the Franco-Cantabrian caves." This opinion, based on the existence of dated archaeological sites which Breuil connected with many of the engraved and painted sites, is no longer accepted.

As in Europe, so in southern Africa Breuil multiplies the stages of artistic evolution. In the granitic district of the northern Transvaal and southwest Africa, he places first the numerous footprints of animals and sometimes of men. Elsewhere everything seems to start with ideograms superposed on naturalistic figures. The mural painting is divided into three geographic groups: the Southern Rhodesian, where the frescoes range from large wild animals, first monochrome, then polychrome, to little scenes with suggestions of landscape and to domestic animals such as sheep and horses; the southwestern, where the people of the "White Lady," who were related to and hybridized with the whites of the preceding group executed both on the Brandberg and in the Erongo Mountains the best and most mysterious frescoes in all of southern Africa; and a third group that Breuil distinguishes from the other two, that of the Bushmen, the "little men," whose frescoes "precede, accompany, and follow the admirable art of the foreigners." This grouping is not accepted by Schofield, who regards all the mural works of southern Africa as attributable to the Bushmen alone and believes that they are all relatively recent. He objects that the alleged relations with the Mediterranean should take into account the graphic conventions. From this point of view the so-called Cretan aspect of the "White Lady" is nothing but a romantic illusion: one cannot take for Cretan or Egyptian a personage

---

*52 Australian bark painting of the nineteenth century. A carefully colored bird laying eggs outlined with dots.*

*53 Ivory pendant with lines and notches, from Paleolithic Europe. The ornament has a fine polish.*

whose eye is indicated by a simple spot of color, a proceeding unknown to Cretan and Egyptian representations where the treatment of the eye carries a very precise and quite different graphic signature.

The quarrels about southern African rock art seem rather secondary to certain prehistorians who, like Erik Holm, think this phenomenon should not be approached with the mental restrictions indispensable before Franco-Cantabrian art. As a matter of fact, all that is forbidden in the way of interpretation in Europe is, for Holm, permitted at last in Africa, because in Africa a long, coherent, unified tradition has been transmited to us orally. We can therefore refer the subject matter of the art to an historical or legendary tradition which is entirely missing in our studies of European prehistoric painting. The representations in the Drakensberg Mountains, for example, have been dated in the seventeenth century by those who apply methods which would be valid for French and Spanish caves. This would make them subsequent to the invasion of the Bantus which drove the aboriginal hunters back into the central mountains. Holm considers that the Drakensberg works were executed earlier, before the Bantu invasion. Working from the content, he points out that it would be difficult to explain why a defeated people should after its flight have evoked only the peaceful images of a happy past; further, that in more recent periods the frescoes do not fail to relate the furious combats of little Bushmen and big blacks armed with shields.

The "Paleolithic accent" does cling with strange persistence to the very fine older engravings at Maretjiesfontein and Leeufontein in the western Transvaal — the subjects are the eland and the rhinoceros — and to the very beautiful polychrome compositions of Silozwane and Nswatugi in the Matopo Hills in Southern Rhodesia. Although this activity cannot be issued a dated birth certificate despite the belief of several authors that it is parallel to Western rock art, it preserves echoes in southern Africa, which were alive until recently among the last of the Bushmen.

---

*54  Polished ax. The tool attains the beauty of a work of art through its technical perfection.*

*55  The Venus of Laussel (Dordogne), or "The Woman with a Horn," is, with the Venus of Lespugue, the most celebrated of the prehistoric Venuses. In its original site the bas-relief (today in Bordeaux, Musée d'Aquitaine, Lalanne Collection) was seen from below and thus seemed lighter. Traces of red ocher show that it was painted. The series of curves around the pubic triangle is of rare delicacy. The personage holds a horn adorned with incisions, which has been interpreted without much reason as a musical instrument. As is frequent in this theme, the face is featureless, but hair, clearing the neck, falls down the back. The masses in this rather shallow relief are excellently organized. The small frail hand with its tapering fingers is placed on the belly; in most other Aurignacian female representations the forearms are joined at the level of the waist or the breasts. The power of a goddess of fertility emanates from this masterpiece.*

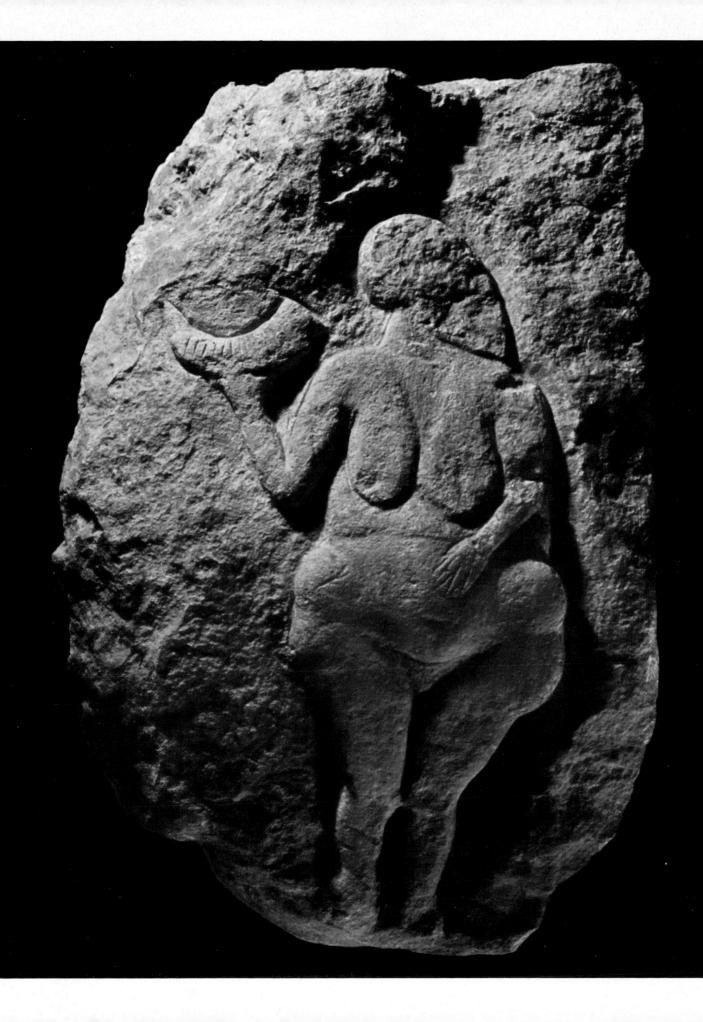

In central Africa Frobenius observed Pygmies drawing by the rising sun pictures of the animals to be hunted. Following him, Holm devoted himself to a careful analysis of such rites and their connections with the animal representations. Like Wilhelm Bleek, he collected stories to reconstitute a conception of the universe that would be at the root of all rock art, for hunting rites do not suffice to explain painting in a world where animals have a more complex symbolic value. A typical list of animal symbols culled from the tales and legends in which the African soil is so fertile begins with the mantis, an insect that incarnates life and manifests itself particularly in the form of the eland. Acceptance of metempsychosis allows belief in a continual passage from living creatures to matter. A broad dualism — something like the male and female complementaries of present-day theories of prehistory in France — splits the universe. The eland, female emblem par excellence, can be identified with the full moon. The horns of some mammals, among them the ox, are lunar symbols. In practice this cosmology means that an antelope with rudimentary limbs, for example, represents the waxing moon. Believing that these associations are disseminated through all prehistoric civilizations, Holm extends them particularly to Franco-Cantabrian art, "genial and enigmatic," whose meaning would be "virtually unknown" without the African points of reference. For him the statuette from Sireuil (Fig. 79), with its child's arms and legs, is "a not fully developed young girl, to be compared with the lunar antelope with rudimentary limbs."

It is difficult to deny the existence of symbolical analogies that can be observed across widely separated cultures originally of the same structure. Holm cites animals transformed into signs of the zodiac. We shall add a curious survival noted in southwestern France where the names given to domestic oxen — when they do not recall the color — refer to the phases of the moon according to the disposition of the horns: "Banou" for animals whose horns point downward — waning phase — and "Chabrol" for those whose horns point upward — waxing phase. However, it is impossible to follow Holm when he interprets the "Sorcerer" at Les Trois-Frères, for him a forbear of the cosmic divinities and demons, as a figuration of the sun accomplishing his journey by dancing across the sky.

In connection with Western rock art, we have touched on the absence of specific cosmological representations and timidly suggested an animal symbolism related to the great rhythms of nature. But of course the question was merely raised to show how inadequate, how very abstract, past

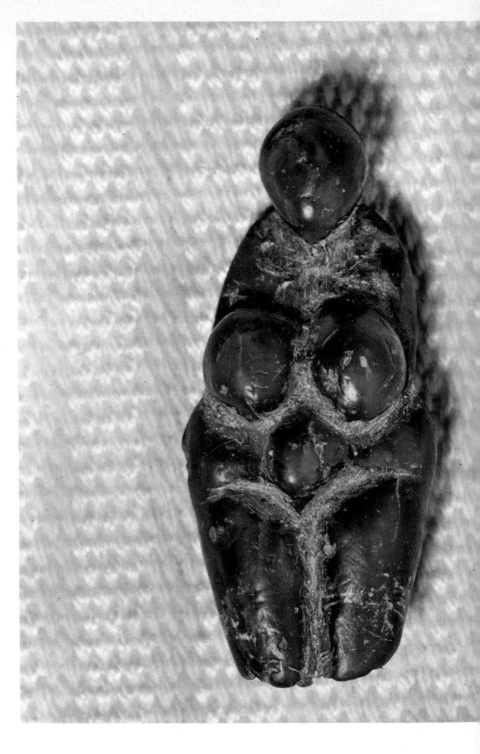

56 *Venus of Balzi Rossi (Ventimiglia. Three views). The heavy masses are bunched together. The head, which lacks features, is but one of these masses; its insectlike forward inclination is characteristic.*

and present systems of explanation remain. It is extremely rash to interpret a Western relic in the light of observations, generally of an ethnographic character, made in Africa — to conclude, as Holm does, for example, that an engraved mammoth of La Madeleine represents the rain myth; such a myth may be thought rather far removed from the preoccupations of reindeer hunters who, living without agriculture in a climate without warm seasons, would have to be credited with gratuitous speculations on meteorological phenomena. It is no less risky to evoke the fertility dance of Bushman women in connection with the foreshortened bison on the ceiling of Altamira.

But there is no doubt that the brilliant ensembles of the

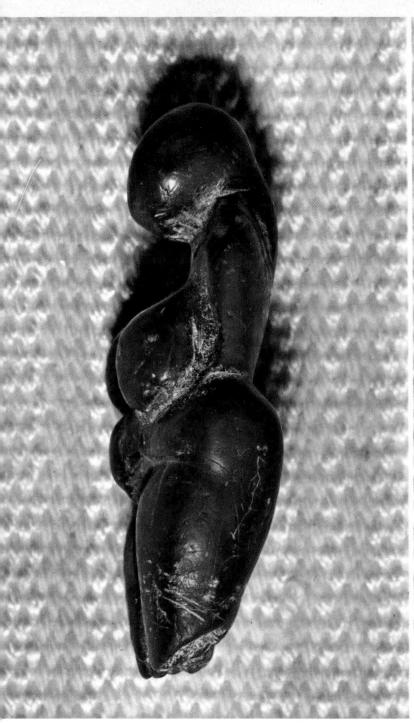
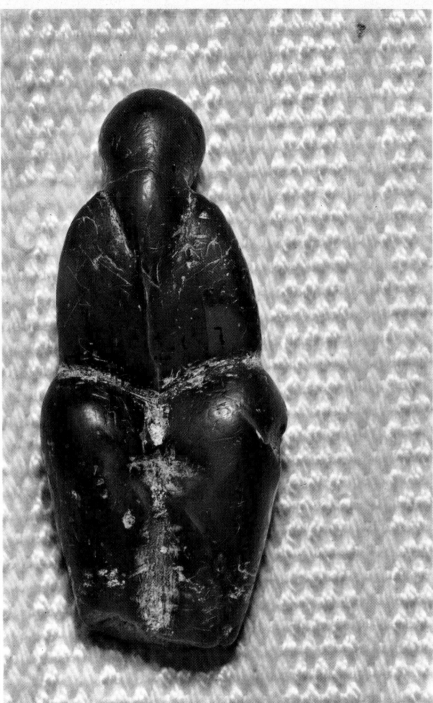

Drakensberg range — those antelopes underlined with white disposed on a bluish background — belong, by the dignity of their presence, with the great realizations of the West. In them the unity of inspiration of the best prehistoric art, whatever might be its origin, is unquestionably contained like an immense secret.

In the other regions of Africa, and even in southern Africa in the more recent periods, it seems — with some exceptions, generally engravings — that despite the survival of rock art the underlying mystery was lost, as in the West. Painting persists, but lapses into engaging chatter, humor, anecdote, translated into lively, very spirited narrative (Fig. 48).

## The Sahara

From this point of view, the now celebrated art of the Tassili is an enduring and varied realization. It ranks first in a vast ensemble whose centers, from southern Oran and the Moroccan High Atlas to the Ennedi plateau, punctuate the map, each year more complete, of the Black Continent. An important climatic fact provides the key: there was a time when the Sahara was green. The growing dryness of the climate in protohistoric times put an end to the raising of oxen in this massif, now a desert, the richest in the world in rock art, with more than 15,000 paintings and 30,000 engravings.

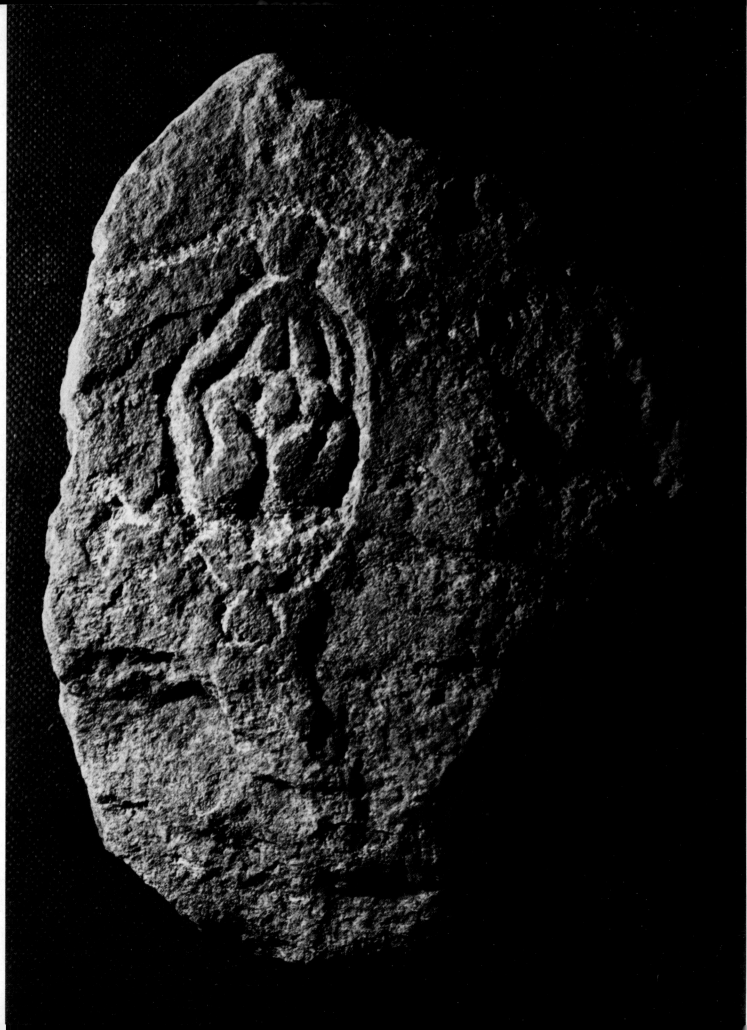

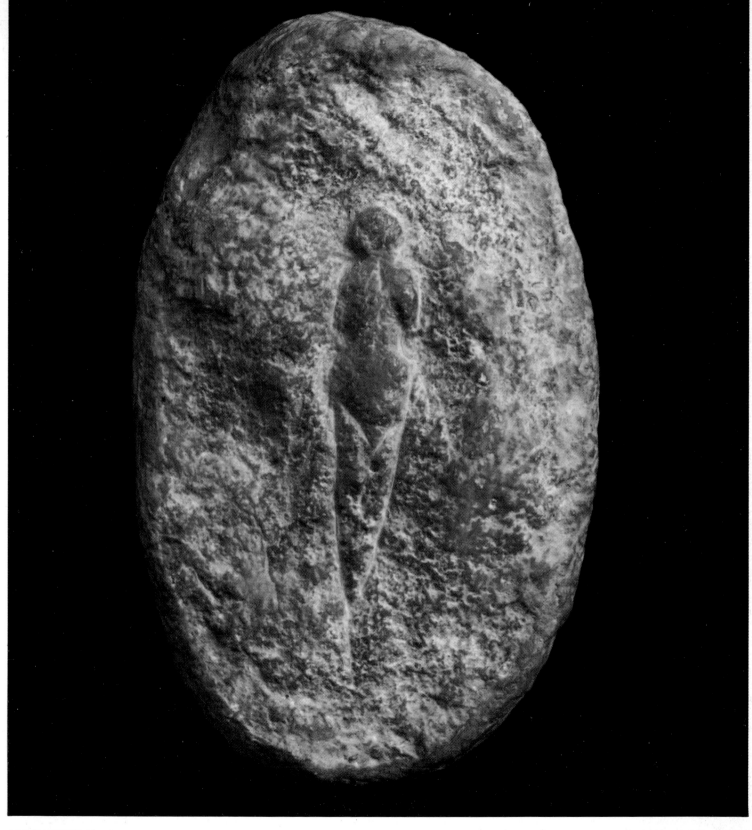

57 This two-headed figure, a very shallow relief treated like an engraving, belongs to the series of human representations found by Dr. J. G. Lalanne at Laussel (Dordogne). Its interpretation, and even its decipherment, are much disputed. Some have seen it as a copulation, others as a birth. According to A. Leroi-Gourhan, it is a single figure that has been carved over; like most of the Venuses, it is inscribable in a lozenge. The lower head might be a first attempt before the piece was turned around, and the specimen could thus be a retouched female representation. Whatever it is, it is of mediocre quality.

58 Small Venus from the Abri Pataud (Dordogne). A late work, it is of exceptional slenderness.

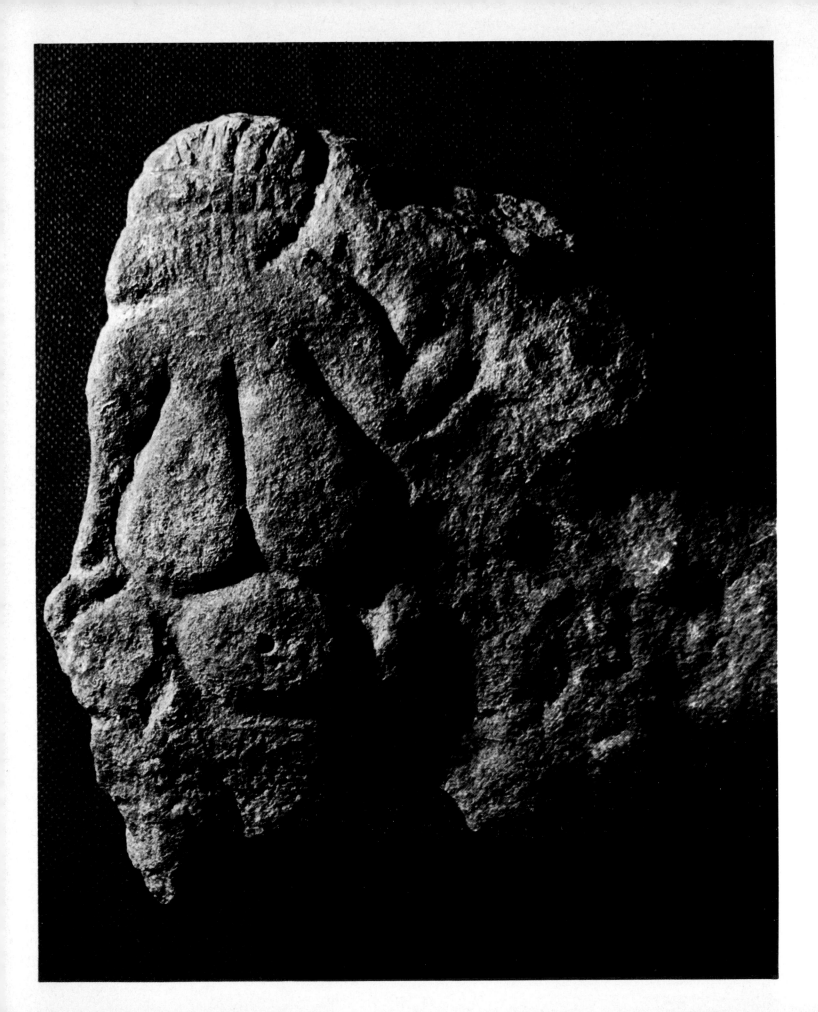

Ranging from species now departed from the region, such as the rhinoceros, the elephant, the ox, and the great buffalo (*Bubalus antiquus*), to the present fauna, with the horse, the mouflon, and the camel, the works spread over a rather lengthy period. Broadly speaking, the drying up of the pastures and the introduction in Africa of the camel (toward the beginning of our era) serve as landmarks for approximate dating. The equipment of the human figures, furnished now with axes, throwing sticks, bows, and javelins, now with sabers and guns, point unmistakably to an extended activity prolonged until a very late date.

The technique of deep engraving, characterized by a line tracing a V- or U-shaped furrow, sometimes almost half an inch wide and perfectly polished, or by a less careful and less regular succession of small conical holes, or peckings, can furnish only imprecise chronological indications. The tools were not found on the sites themselves, although sometimes, according to Lhote, striking implements of Neolithic type turned up in the neighborhood.

The polishing of the grooves can hypothetically be at-

---

59 *Another Venus of the Lalanne collection. The most striking elements are the extravagantly large breasts and the hair—standard for the type—which falls over the face, here covering it entirely. The outstretched right arm may have held an object.*

---

tributed only to the highly practiced handling of a hardwood stick and damp sand. The rock, a current cross-section of which would be light, bears a patina, a sort of dark coating due to oxidation in a warm and humid climate. The degree of oxidation is not, however, a conclusive means of dating. Humidity, exposure to sun, and mineral composition of the rock all modify the speed of the process. Lhote admits that the method permits only rough comparisons on the same slab, for it can happen that engravings of camels are darker than those of elephants, which lived in the region earlier. Like painting, then, engraving sees its chronology reduced to the succession of themes. Thus Lhote distinguishes:

A "Bubalus" or "Hunter Period," in which the engravings are of large or medium dimensions, with a polished or a pecked groove, dark patina, archaic animals and personages armed with clubs, throwing sticks, axes, and bows, but not javelins. Unfortunately some species in all likelihood already domesticated, the ox and the ram, appear, in this group, indicating a relatively late date. The designation "Hunter Period" needs re-examination.

A "Period of Cattle Herdsmen," in which the ancient buffalo (*Bubalus antiquus*) disappears while the style, previously naturalistic, tends to a certain schematism, a certain glibness. The patina is a little lighter, the works are not as large, and the personages are armed only with bows.

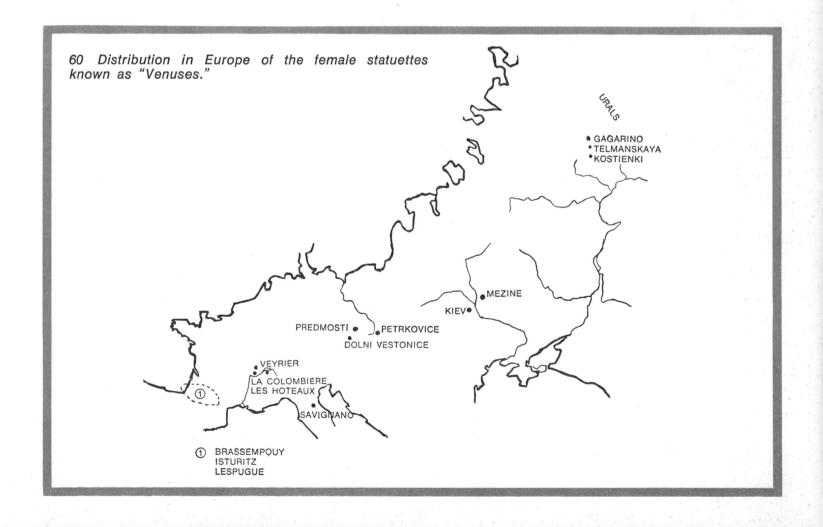

60 *Distribution in Europe of the female statuettes known as "Venuses."*

A "Horse Period," divided into three stages. In the first, the "Chariot Stage," the elephant is rare, the other large pachyderms are missing, the domestic ox persists, and there are numerous dogs and mouflons. Of conventional style, the figures are small, though there are some over three feet high; they are armed with the javelin and round shield, and already bear a dagger. The oldest chariots have only one shaft and show the steeds in profile; the others, which sometimes have several shafts and may have been intended for transport, are more schematic. Let us recall that well-known passages in Herodotus and Strabo tell of the use of chariots by the Garamantes. The "Horse-with-Rider Stage" differs little from the preceding, but is distinguished by the presence in the central Sahara of Libyco-Berber written characters introduced by the horsemen. The third stage saw the appearance of the camel and an incipient degeneration of the figures. Finally, we have a "Camel Period," unfolding small-scale representations in a childish, uninteresting style. The horse becomes rarer, and when it appears it is harnessed in Arab fashion.

The classification just outlined, based on engraving, appeared valid for all the sites of northern Africa which were known at the time that Lhote developed it. It is a rather complicated matter, however, to fit into his scheme the abundant paintings of the Tassili. The paintings are naturally concentrated in sandstone shelters, except for some on granite in the Hoggar. The discoveries in the Ennedi and in Mauritania cast doubt on the chronological classification, and those of 1956-1957 in the Tassili cracked the ordering framework entirely.

Lhote distinguishes no fewer than thirty styles; unfortunately, these are merely classifications by subject: style of the "round-headed men," of the "little devils," etc. But it is apparent from this enormous inventory that the Bubalus Period is, as far as we now know, barren of painting, while the Herdsman Period, the richest in paintings, with more than ten thousand figures, does not include any engraving. In the succeeding periods — Chariot, Horse, and Camel — painting and engraving coexist. This observation would tend to show that the Tassili painting began relatively late.

An example from the Ténéré will demonstrate a highly characteristic gap between cultures. In 1959 it was learned that M. Mauny, a member of the Berliet Ténéré expedition, had discovered an archaeological site of very great antiquity (early Paleolithic) south of Djanet, near In-Afellahlah, along the upper course of the Wadi Tafassasset. Pebbles and pieces of quartz crudely chipped on top, doubtless by human hands, appeared to date back the peopling of the Ténéré, now the most arid part of the Sahara, by some 600,000 years. But intermediate stages are strangely lacking between this venerable date and the cultures that have left more complete remains in this region. All these are rather recent, such as those of Adrar Bous, where Lhote found tools dating back only a few thousand years and pottery whose forms and even decorations present similarities to those of the Herdsman Period of the Tassili. This observation has been the point of departure for the hypothesis of a pastoral civilization with herds of oxen spread over a considerable area, radiating from the old course of

the Wadi Tafassasset. Lhote even supposes that this culture extended all the way to the Chad. In reality it is possible that the Wadi, whose course has not been reconstituted in its entirety, did not go beyond a lake in the Ténéré. Be that as it may, there is a wide hiatus in the sequence of Saharan migrations, and the murals so far inventoried in this region were not produced before that hiatus.

The difference between the early engraving and the painting is not merely that of chronological order. It lies in the inspiration and the very nature of the works. In the three main groups of archaic engravings — in southern Oran with the lion and the ram carrying a disk between its horns in the Fezzan and in the Tassili with the spiral and the coarsest copulation scenes in prehistoric iconography — a remarkable plastic quality is associated with a sacred accent. Isolated and almost motionless, the engraved animals seem drawn as though to convey an important meaning.

---

*61 Unlooked-for beauty in a hard stone disk, whose translucence is revealed by the flakes chipped from it.*

*62 Harpoons. These artifacts demonstrate the effectiveness of tools perfected for millennia and meeting every need.*

---

According to Lhote, they are the work of white peoples of Capsian culture related to Cro-Magnon man. The painting, on the other hand, secular and anecdotal, derives its interest from the animation and vitality concentrated in the human representations, qualities that were to mark subsequent Negro art, together with a somewhat arid sureness in the elegant rendering. Lhote does not hesitate to identify this painting as the first Negro art and an entirely original development, born in that region and not dependent on the other regions of rock art.

The links which have been observed with the art of the Spanish Levant seem to him to be of late date: the famous bell-shaped skirts of the women of Cogul in Spain are of Cretan origin, according to him, and their counterpart in the Tassili would have been imported from the eastern Mediterranean about the twelfth century B.C. The "round-headed style," peculiar to the Tassili, is found nowhere else. But Lhote notwithstanding, the scenes with personages and herds of the Period of Cattle Herdsmen show bonds, as yet undefined, with late elements of southern African art, which may be attributable to a common origin so far unknown.

One of the spectacular results of the work accomplished in the Tassili is that the route of the war chariots drawn "at a flying gallop" has been brought to light. The warrior population that utilized them has left traces as far as the Adrar des Iforas, where representation of this piece of military equipment has been recorded, and may even have reached the Niger near Gao.

The cattle herdsmen seem to have come from the east, and they are believed to represent a second wave of white men, to whom are attributed the small stone sculptures of the Hoggar — animals of massive body and anthropoid idols of small size and rather good quality. Their descendants are supposed to be the present-day Peuls, who, herdsmen themselves and not Negroes, are probably related to the Ethiopians. However, as the frescoes themselves show, several human types lived together in the Sahara and their hybridization is of long date.

The paintings tell an absorbing and for us still confusing story of the cultural waves which moved across Africa.

Relations with predynastic Egypt are attested in the Tassili by various details: styles of hairdo, "bird-headed goddesses," weapons, symbols, boats of the same type as on the Upper Nile, etc. Should we follow Lhote who sees in the Bubalus artists of the Sahara the fathers of Egyptian

a

63  *Evolution in the form of the Venuses.*

*(a) Engraving from La Couze (Dordogne); (b) Laugerie-Basse (Dordogne) retaining the backward curve shown above; (c) Dolní Vestonice (Moravia) somewhat stiffer than; (d) Balzi Rossi (Ventimiglia); (e-f) The Venus of Willendorf (Austria), a rhythmical cumulation of opulent forms; the hair covers the whole head.*

b

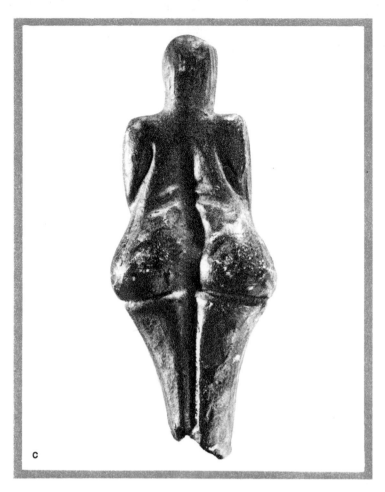

c

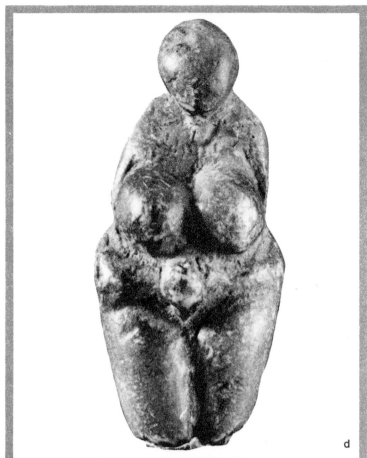

d

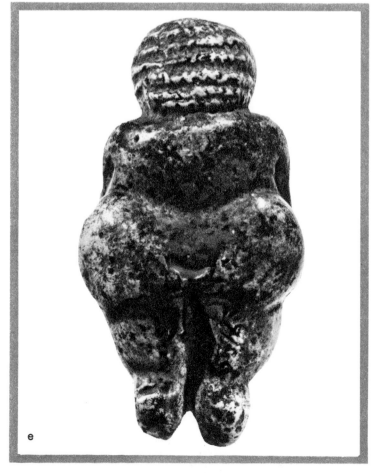

e

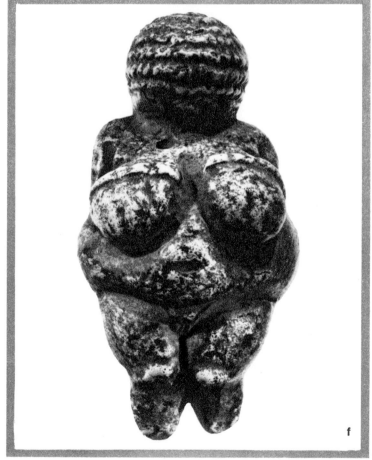

f

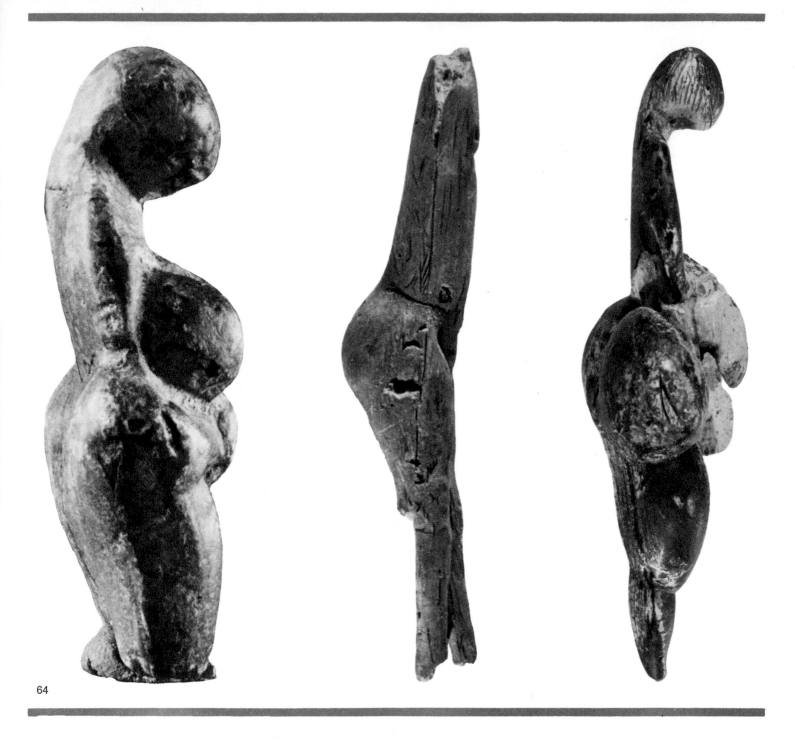

64

64 *Profiles of the Venuses of Balzi Rossi, Laugerie-Basse, and Lespugue compared.*

65 *Venus of Lespugue (Haute-Garonne), a masterpiece of the so-called "Aurignacian" sculpture. The triangle that supports it in back is difficult to interpret. It has been viewed as a kind of seat, but should doubtless be regarded as a peg serving to stick the statuette in the ground. Here the essential volumes are grouped in the central portion of the lozenge, which supplies the basic rhythm. The ivory is mutilated at the belly. A superb greenish patina covers this incomparable piece, one of the treasures of the Musée de l'Homme in Paris.*

art? To be sure, Egypt is in Africa, and the current excavations in Nubia are beginning to shed light on a crossroads of capital importance. But how can we forget that this civilization, which was the first to develop writing and monumental architecture, also had contacts with the East, and that it was thanks to those very contacts that it was able to leave prehistory behind.

In general the African continent, from which in this context Egypt, precisely, must be excluded, has remained (like other parts of the world where a prehistoric way of life has perpetuated itself) outside the currents of civilization that led to the creation of the great empires and to the modern industrial world. From this point of view, it could

even be said that all of Negro sculpture is a kind of prehistoric art. It is certainly not without connection with the painting of the rock shelters. In the Tassili stylistic similarities have been noted, and even a representation of a sculptured mask. A capital artistic phenomenon for Negro cultures, the wooden sculpture of Africa is linked, as prehistoric art doubtless was, with rituals, the dance, and other collective manifestations, but it has features that are not prehistoric. Its initial naturalism degenerates into allusive forms ending in hieratic symbolization. Stiff lines succeed supple contours. Animal representation is subordinated to human representation. A stage has been irreversibly cleared: even though the animal might be the "mythical ancestor," it is no longer considered in itself but rather in relation to man or, more exactly, in relation to the male-female couple on which the sculptor's attention is concentrated. The animal counted in the obscure past. Now only the fate of the human couple counts.

Here we have the plane of cleavage from which the nature of prehistoric art emerges by contrast: prehistoric art is the art of a civilization that lived the man-animal relationship as a human reality.

## Australia

A demonstration of the shift of values that serves as a line of demarcation between prehistoric and primitive art could be furnished by a close examination of the boundaries between these two arts in regions of the globe where, as the formula has it, "the Stone Age has perpetuated itself." We can do little more than mention the principal zones where it would be necessary to delimit closely the persistence of an "archaeo-civilization" and define the hybridizations between the two arts.

The work has been done for Australia, where, since the publications of J. Bradshaw in 1892, rock paintings have been thoroughly studied. Here, too, two styles have been distinguished: a naturalistic one in the north, in the northwest (Queensland, Arnhemland with the important center of Oenpelli, and the Kimberleys), and in the south and southeast (New South Wales); a geometric or more or less schematic one in the southwest and southeast. These two styles appear together in certain regions.

It may seem strange that naturalism did not produce in Australia the same brilliant animal sequences as in Europe and Africa. Lommel attributes the fact to a schematization more precocious here than elsewhere. Besides, many ancient works have been destroyed. Not too long ago — in the nineteenth century — the last aborigines were still repainting the frescoes and preserved an oral tradition — today almost entirely lost — dealing with the mythical realities represented. Thus the famous "wondjina" figures, white personages outlined in ocher, without a mouth and with feet represented as footprints, were taken for effigies of aquatic or fertilizing powers, and the snake, which is often present, was identified with Ungud, a reptile-god dwelling in the bowels of the earth, master of the transit between life and death. Some other animals — lizards, birds, kangaroos, and especially fishes — are delineated in red

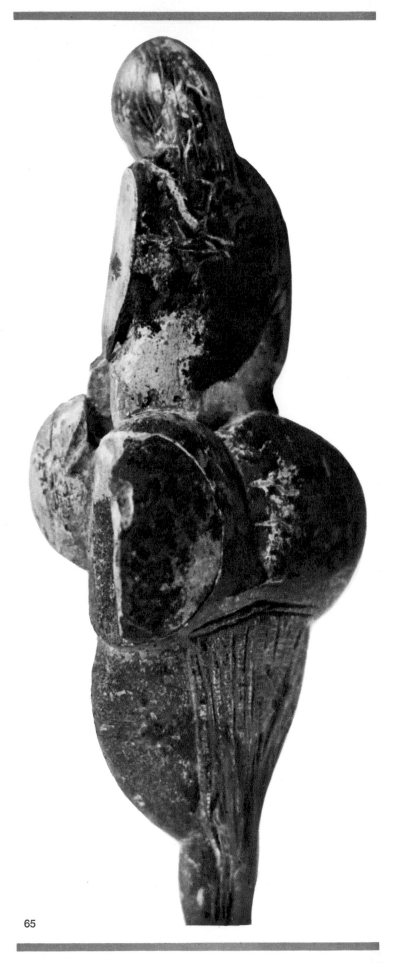

65

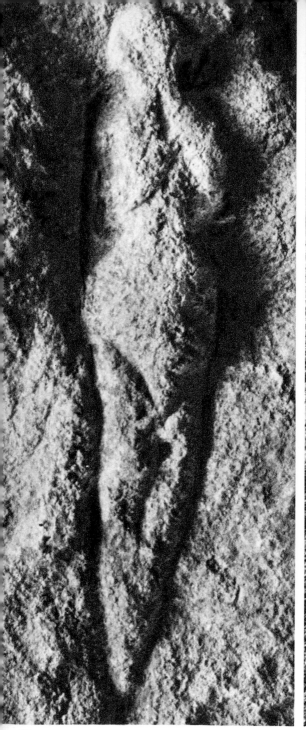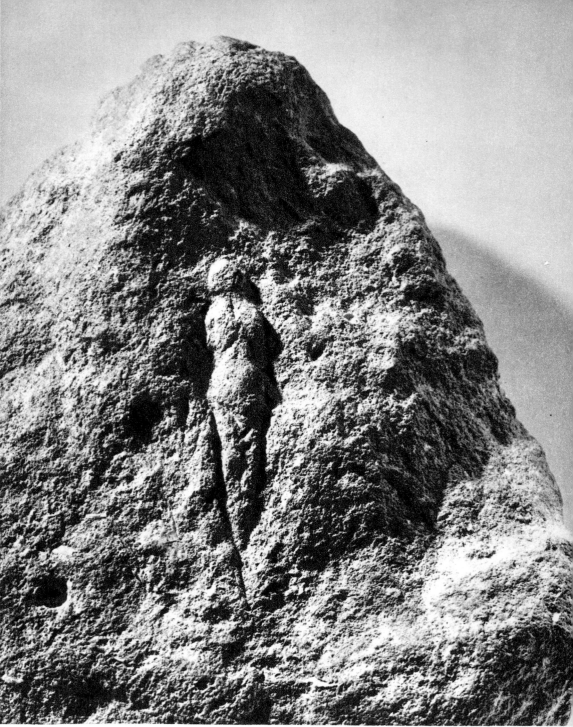

on rocks in the south and are added, with wood charcoal or light clay, around the "wondjina" figures — without constituting a great animal art.

A peculiarity of Australian graphic technique is the depiction "by transparency" of, for example, the digestive tract, fish bones, or the heart. As we have already noted,

---

66 *Venus of the Abri Pataud (Dordogne), and detail.*

67 *Venus of Mezine (Ukraine), an austere, schematic figure.*

68 *Terme-Pialat (Dordogne). In these female figures the relief is obtained by deep engraving.*

---

this practice is absent, with few exceptions, from the great naturalistic arts. Human representation also offers some original features: an aureole of straight lines indicates hair; the face is often round, or the shape of the head is indicated by an arc or a crescent. Copulation scenes are numerous, particularly in the dotted figures. Series of squatting personages, generally female, develop into caricatural graffiti in the northwest and the Kimberleys, where they are taken to be specific sexual evocations. Many of the figures are schematic. The "she-devil" of Ngungunda 2 is composed of a series of thick red lines that form a kind of framework of fairly striking effect. The little figures of light animated aspect in so-called "elegant style," which are anterior to the "wondjina" figures, and the mediocre

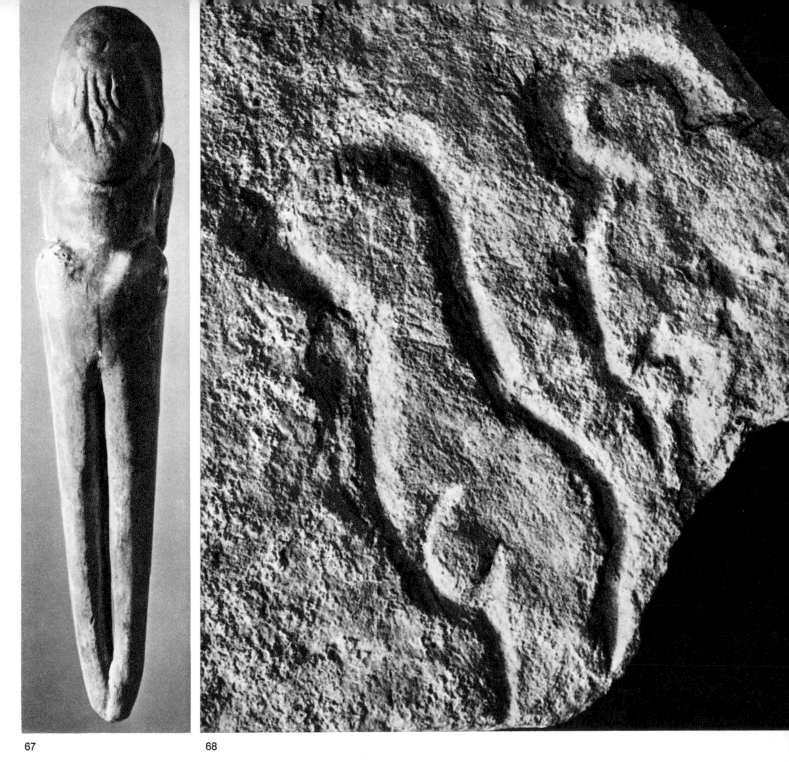

67                              68

representations of great size found in the southeast, complete an abundant ensemble, so varied that foreign contributions must be assumed to account for it.

Poorly documented as it is, the study of animal representation would gain from a comparison with the production of painting on bark (Fig. 52). It is known that bark painting, an activity surviving to our day in Arnhemland, repeats iconographic peculiarities of the mural art in the earliest good examples. The work is very carefully done and testifies to a real effort at refinement in the decoration, by the play of colors as well as by the addition of rows or sprinkling of dots. The recent panels, on the other hand, are often merely childish narratives translated through poorly stylized animals overlying a profusion of hatchings.

The best specimens of American Indian petroglyphs (Fig. 50-51) and paintings on hide (Fig. 49) can usefully be compared to the Australian aboriginal art, as well as the works of certain populations of Central Asia, the Arctic, or the Middle East. Even in the Indies, ancient examples of rock art are found. But only a wordwide comparative dating system, based on a still problematic concordance of the industries, could give an inclusive picture.

## Summary

We conclude our investigation of mural painting with a provisional definition:

Prehistoric mural painting is characterized by the nature

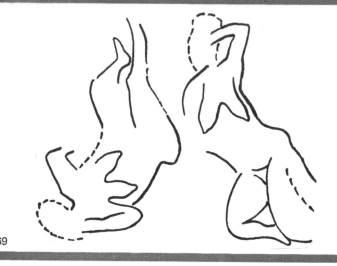

69

69 *The Venuses of La Magdeleine (Tarn), recumbent like Parthian statuettes. In the sketch, they resemble Matisse figures.*

70 *Laussel (Dordogne). This male representation, miscalled "the archer", is another of the pieces found by Lalanne. It is carved in shallow relief. A belt is inscribed at the waist.*

71 *Angles-sur-l'Anglin (Vienne). Erect ibex of a great freshness of inspiration.*

72 *La Marche (Vienne). One of the very few human heads rendered in detail in prehistoric art. The face is prolonged into a muzzle. The almost horizontal jawline is curiously terminated by the ear.*

72

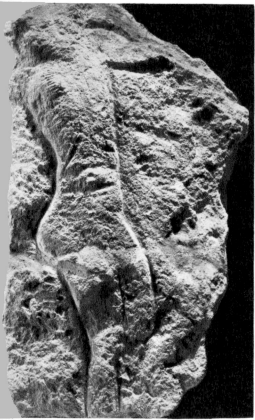

70

71

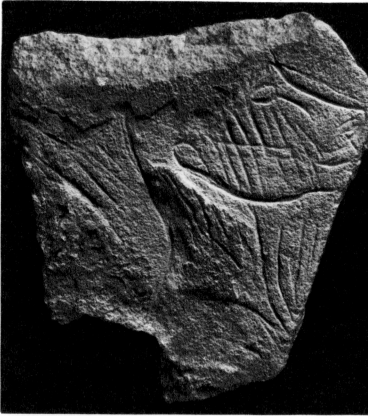

73

73 *Bourdeilles (Dordogne). Bovids in bas-relief in an excellent style.*

74 *Le Roc-de-Sers (Charente). Well-modeled horse and bison with boar's head. (Opposite page.)*

75 *Le Tuc d'Audoubert (Ariège). Bison modeled in clay. (Opposite page.)*

74

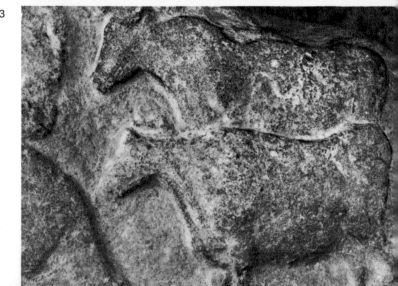

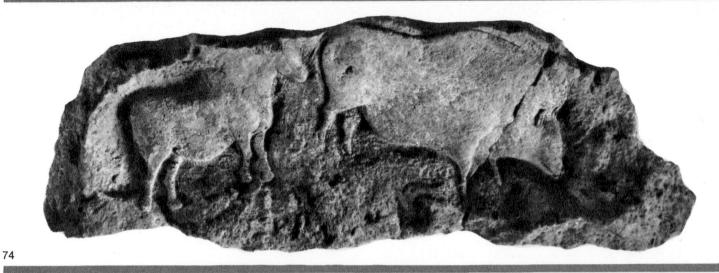

74

75

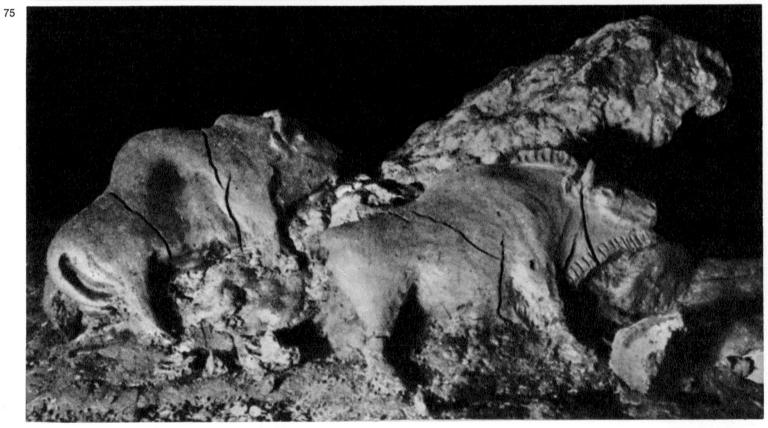

of the contact between man and the animal world. The animal is the primary subject and is represented for its own sake, as it were. That, at any rate, is the impression given by the frescoes of Franco-Cantabrian art and, at times, by certain African panels. There can be no doubt — their high degree of "presence" proves it — that the portrayal of animals obeyed symbolical, or rather metaphysical, dictates that escape us, but whose existence is confirmed by the associations among the figures themselves and with a series of signs. In truth, the effectiveness and often the very remarkable beauty of the picture as a picture and our ignorance of the real reasons that motivated it are the only source for our feeling that animal life was recorded for its own sake. The illusion has to do with the fact that to man the animal as prey is always more occult, more respected, more admirable than the animal as cattle. For the rest, any attempt at an absolute reconstitution of the meaning of the mural art is utopian, and prudence asks that we aspire only to a kind of phenomenology. If, on the other hand, we consider the quality and not the meaning of the prehistoric masterpieces, they become accessible to us, like those of other civilizations. Yet it would be presumptuous to believe that the quality of the great painting of the Upper Paleolithic was due only to the particular treatment of space or to the sureness of an already mature technique. The elevated character, the intensity, and — let us admit — the mystery of the implied content also contribute to the universal value of this art.

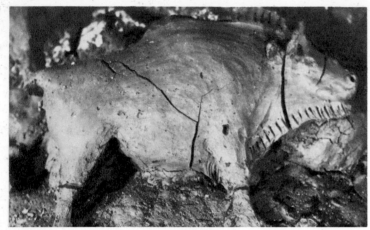

76

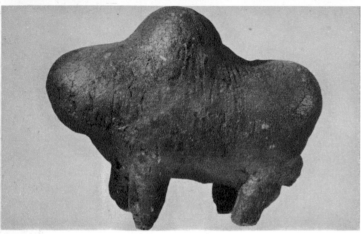

77

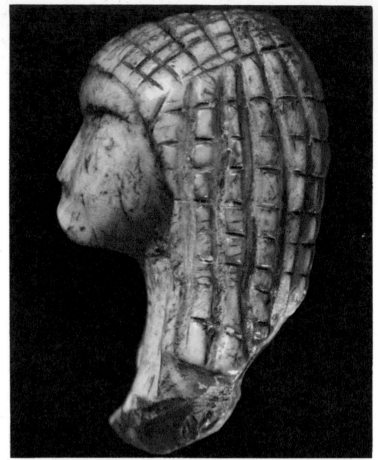

78

79

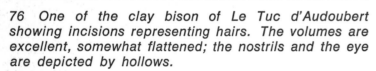

76 One of the clay bison of Le Tuc d'Audoubert showing incisions representing hairs. The volumes are excellent, somewhat flattened; the nostrils and the eye are depicted by hollows.

77 A simply modeled piece from the Chad region. Compare with the clay bison of Le Tuc d'Audoubert: the Franco-Cantabrian work has captured the breath of life, while the African one offers a purely conventional form.

78 Ivory head from Brassempouy (Landes). Here the female face is for once well detailed, with a jutting forehead and high cheekbones. The carefully treated hair is patterned like a checkerboard and falls gracefully, revealing the long neck. The chin is very pointed. From the front the face is heart-shaped, as in African Negro sculpture. This is a most harmonious work.

79 Venus of Sireuil (Dordogne). In this rather slender figure the breast does not have the fullness characteristic of the other Venuses.

80 Venus of Tursac (Dordogne). The form retains the customary rhythm with a strange movement that lifts the right leg.

## ENGRAVING, SCULPTURE, AND ART MOBILIER

### Engraving

At first glance engraving seems like a poor cousin of painting. It is nothing of the kind. We shall be concerned with two aspects of this art: its associations with other techniques and its authority and independence as a key activity in the complexes where it reigns alone.

The connections between engraving and painting derive from the importance of the contour in prehistoric art. Careful examination of the engraved furrow shows that painting is sometimes anterior, sometimes posterior, to the carving of the rock. In the Nave at Lascaux, where many examples of the overlapping of the two genres occur, it can be seen that the animals were engraved after they were painted. Operative here seems to have been a demand for precision and permanence of the figure. It is particularly noticeable in the checkerboard divisions of the signs known as blazons under the feet of a cow on the left-hand wall of the Nave. The nine boxes, whose importance is marked by the richness of a polychromy that, besides red, black, and brown, exceptionally includes a frank sustained violet-mauve, are carefully separated by engraved lines. Although this division of the colored geometric areas was carried out after the painting, it does not seem to have been a subsequent revision; the two techniques were utilized in the execution of the motif as part of a single undertaking.

In other examples, the cervico-dorsal line of animals — the guideline of the drawing, as we have seen — is the only one stressed by engraving. The artist, in sum, thinking chiefly in terms of silhouette, employs both modes of expression, especially for small and medium formats. Already in the "macaronis" the thick trace made by the finger dipped in clay amounts to a crude engraving on a soft surface. Incision, for a culture with a fine choice of cutting tools, is a means always available, literally always ready to hand — more directly so than painting, which demands a special material.

Engraving never better reveals its spontaneity than in the brillant figures drawn in mud at Niaux. On a clay bank in the Salon Noir, a salmon (Fig. 113) is traced very firmly with an expressive delineation of the fins, the eye, and the tail, which is especially well rendered and of exaggerated dimensions in relation to the total length of the fish (14 inches). In another part of the cave is a bison drawn in a way that recalls the paintings in black line in the Salon, with long hairs depicted by parallel strokes; the holes pricked in the rock by the fall of drops of water were completed by fletched elements to represent wounds on the animal. The flourish of the whiplike tail and the detail of the head, preceded by a sign in the shape of a parenthesis, compose a brilliant specimen.

We shall not give a list of the innumerable engraved figures in the decorated caves, sometimes combined with painting and sometimes constituting homogeneous ensembles (at Lascaux both categories occur with very fine specimens

of stags and horses, the Chamber of Felines, etc.). The publication of the figures of Le Gabillou (Dordogne) in 1964 has shown that even an entire cave can owe its rich decoration, of an excellent style, almost exclusively to engraving, which in this instance may have been used to fulfill the role of painting because of the narrowness of the underground passages. The iconographic structure of these panels corresponds to those of compositions elsewhere painted on a larger scale.

The combination of engraving and relief brings us to the frontiers of sculpture. The prehistoric artist, very alert to the potentialities of the site, would add a line with the burin as readily as he would add a stroke of color to the natural swelling of a wall, so susceptible was he, as has often been remarked, to the suggestions already materially incorporated in the base. His responsiveness to the tacit solicitations of volume is one of the keys to "art mobilier." There is practically no difference in creative approach between a relief and a deep-cut engraving. The large salmon of the Abri du Poisson (Les Eyzies) is a deep engraving, whereas a horse's head in very shallow relief at Commarque is already a sculpture.

Engraving manifests autonomy in certain panels where it is entrusted with themes that seem to fall within its province rather than that of painting. Broadly speaking, the repertory of animals and signs extends to all of prehistoric art. However, certain subjects occur more frequently in engravings: vulvar representations, little human or semi-human personages, and animals rarely attempted or altogether absent in painting and sculpture. An additional group that ranges from the bird to the hare supplements the usual cast of animals.

Above all, it is in engraving far more than elsewhere that one notices that total freedom with regard to spatial order in which some, like Giedion, would see the essence of prehistoric art, unhampered by "our rectangular way of looking at things."

If references to a groundline are lacking in painting, except in the final period, the scenes are nonetheless treated with a general awareness of horizontality and verticality. In the large panels the superpositions are usually not placed slantwise, and the so-called upside-down animals occupy ends of pasages or recesses where they most likely obey a topographical suggestion. At Altamira improvisation inspired by local features is carried to an exceptional pitch. Before a panel to be painted the artist "thinks rectangular" or at least places the animal in a position that deviates from the vertical only because of movement and because the feet do not rest on a groundline. As we have said, the plastic treatment of the figure makes it possible to obtain an effect of natural placement; equilibrium is assured by the alteration of plane for peripheral details and by the distribution of colors.

The same is not always true for engraving where, indeed,

*81 Venus of Willendorf (Austria). The object is meant to be stuck in the ground. Here the conventional forms are carried to an extreme.*

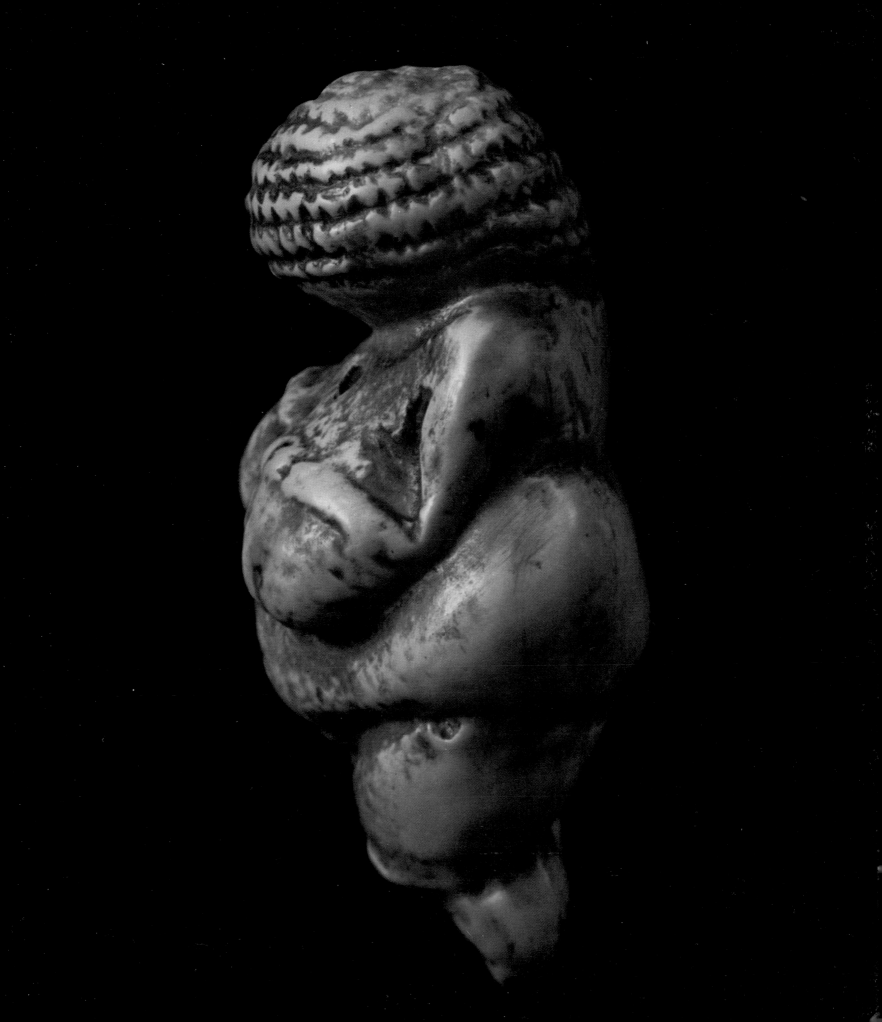

82 *Bruniquel (Tarn-et-Garonne). Throwing stick decorated with a horse in high relief. The animal looks as though it were about to take off like an arrow.*

the orientation of the figures in the snarls of delineations often seems entirely arbitrary. An animal may have to be viewed from the bottom up or crosswise in relation to another, especially in two instances: on the engraved pebbles of La Colombière type (Fig. 91) and in the mural complexes, of which the most surprising are at Les Trois-Frères (there are others at La Mouthe, Pair-non-Pair, etc.).

Several comments may be useful here. First, unity of composition is a function of the sum total of the engravings, not of each individually. An engraved pebble does not in itself have a "rectangular" orientation relative to an observer, since it is a movable base and the entangled incisions it carries must be read by turning it. Then varied figurations are revealed from several angles, just as on objects

of "art mobilier" some animals appear on several faces. Regarding the wall complexes, which are not on an easily handled base but are fixed like paintings, it may be pointed out that, though the figurations are embroiled and extremely difficult to identify, the majority, as a rule, are oriented vertically. The unity of the vertical rhythm is not necessarily broken if anmals are presented head down — as is the case for two reindeer in the right-hand portion, toward the Apse, of the sanctuary of Les Trois-Frères — or very obliquely, as for some bison on the same panel.

A very intensive study of the complexes would, we believe, afford some interesting surprises. In the present state of inquiries, the interpretation of these stupendous panels has yet to be tackled. What is certain is that they have a very special meaning which does not coincide with that of the paintings. We see several reasons for this. One of the most obvious resides in the esoteric tone that engraving takes on in the incommunicable imbroglio of the complex. It is clear that the enormous labor necessary for the detailed execution of an agglomeration which is for us inextricable, corresponds precisely to what is most universal in prehistoric art — in other words, to what is most intimate, most confidential, and most special in it. In this phase of its development, one sees a terrifying world emerge. An irrepressible fear provokes desperate gallops. Creatures turn back haggard. Little masks loom up amid the turmoil of animal life. And to express what we cannot hope to grasp, draftsmanship takes bold chances. The rotations of plane no longer seem to have any other purpose than to display the eye, the sexual organ, a deformation — even at the expense of representational harmony. Strange reworkings duplicate heads. Abrupt plunging views reveal the top of a bison's mane at the same time as the underpart of its nose. Seen from all sides, the animal is no more than an assemblage of fragmentary snapshots. Its natural aspect is as though tortured by this frenzied expressionism.

The tranquil surface upon which the complacently disposed antlers of the painted red deer were spread in sepia tones is replaced by a mad agitation where interest seems focused on bringing into relief an unknown reality. The animal, still constructed according to the conventions of design valid for all of prehistoric art, is treated with a certain indifference to pictorial qualities, in favor of an intensification of the significance attached to its attitudes (heads turned back as at Pair-non-Pair, flight) and to details of its anatomy (eyes, sex organ) which become blatant. A patient process of copying — such as has been accomplished for these complexes by Breuil — can only, with difficulty, itemize the figurations, without penetrating the very strong motives that brought them together.

It must be admitted that, though its import escapes us, this prodigious vision of the animal world and the cosmology it seems to embody exercise a real fascination: one remains for a long time in front of the complexes, discovering on "entering" them, as one does on "entering" the teeming fantasies of Hieronymus Bosch, always new subjects of astonishment — a mask placed at the level of an ear (Fig. 5), or outstretched tongues, or such differences in scale among animals that a movement is created, an orientation among others in the pullulation of a microcosm. Starting from purely naturalistic elements, fitted together in an arrangement which is dense and complicated, but in no way unconsidered, engraving attains to the fantastic.

## Sculpture

Through bas-relief, as we have seen, a certain form of sculpture is still dependent on deep engraving. But prehistoric art has a genuine sculpture, which excels in modeling and work in the round and even achieves an organization of space that is truly monumental.

Modeling in clay may have been practiced more widely than the modest remains of a fragile production would lead one to suppose. If the headless bear of Montespan and the much damaged series of animals accompanying it bring to mind preliminary models or little-cared-for objects of daily use, no such impression is conveyed at Le Tuc d'Audoubert (Figs. 75-76). There, in a last low chamber about 700 yards from the entrance, leaning against a rock projecting in the center, are two bison, one behind the other, modeled in a very fine style. Measuring about two feet each, they seem carried forward, the front portion slightly raised by an irresistible propulsion, well translated by the carriage of the head. The eyes, the horns, and the main lines of the coat are delineated, and an indication of the skeleton, particularly the substructure of the skull in the forward animal, animates the convexities of the clay surfaces, rendered as docile as the skin of a living creature. Seen in three-quarters view, one of the heads, with hollowed round eyes, might be the prototype for all bucrania to come. However, these bison are in no sense ornamental: a profound recognition of animal characteristics is expressed in them, whatever reasons might have motivated their realization. In the vicinity, pieces of clay that show handling have been found — small heaps perhaps prepared to complete the scene or remains of its execution. Be that as it may, the hands that extracted these forms from the loam in that subterranean recess were sculptor's hands.

The great monumental frieze adumbrated in the clay of Le Tuc d'Audoubert is realized, with truly classical breadth, at Le Cap-Blanc (Charente) on the rock of a shelter some 15 yards long. Discovered in 1911 by Dr. J. G. Lalanne's chief of excavations during the exploration of an embankment of Magdalenian hearths, these celebrated sculptures are indisputably, despite serious mutilations, of the highest quality. The site, near a grave that has been removed to Chicago, testifes to a disposition already architectural: a paved

---

*83 Hindquarters of a bovid. There is delicate workmanship in the utilization of the material. (Saint-Périer Collection.)*

ground, a broad stone border forming a curb or socle. The relief of the figures occasionally reaches some 12 inches, and modeling in the round is used. The beauty of these sculptures has been compared, without exaggeration, to that of Greek bas-relief in its maturity.

A specifically prehistoric element, however, disrupts the seemingly relaxed and peaceful order of this procession, whose original impressiveness may be guessed from the remains. It is the composition, which is, in point of fact, something more complicated than the brilliant delineation of a file of horses. A detailed examination has revealed (besides traces of painting in red ocher) a mixture of animal species; it is difficult to say whether these were executed in a single period (Magdalenian III) or whether they were given ultimate form or made even more complex by a later rehandling. The forms of bison and horses are carved into one another, presenting an interesting equivalent of the superpositions noted above. Little bison are on a smaller scale — 10 inches as against the 7 feet attained by one of the horses — in a mediocre style and are executed in sunk relief. These anomalies in the relief, to which must be added a strongly projecting ring on the rump of one of the horses and the "unusual oval depressions" that Leroi-Gourhan observed with side lighting in 1961, belong to a type of composition peculiar to prehistoric art. We see plays on form in these ambiguities, but have no right to consider them pure sport. Quite the contrary, their repetition in other sculptured friezes — particularly at La Chaire-à-Calvin (La Papeterie, at Le Mouthiers, Dordogne), where the theme of the horse carved in a bison and even that of the ring recur; at Angles-sur-l'Anglin (Vienne); and at Le Roc-de-Sers (Charente; Fig. 74) — show the unity of

85

84 Laugerie-Basse (Dordogne). This animal carved from reindeer antler is difficult to identify: it has the posture of a bear but the general aspect of a young carnivore. Its expression of timidity is rather surprising. (Museum of Saint-Germain-en-Laye.)

85 Le Mas-d'Azil (Ariège). Top of a throwing stick decorated with three powerfully realistic flayed horses' heads.

86 Le Souci (Dordogne). Awl adorned with a frieze of engraved horses' heads.

motive behind the deliberate amalgams, which owe nothing to accidents of execution.

The repertory of the sculptured frieze is enlarged at La Marche, Le Roc-de-Sers, and Angles-sur-l'Anglin with other animal and human representations: facing ibexes, a combination of bovid and boar, a bird (Le Roc-de-Sers), a young and graceful ibex drawn upright, and female representations (Angle-sur-l'Anglin). Let us not leave this series dominated by animal bas-relief without mentioning the pillar of Isturitz (Basses-Pyrénées) with superpositions

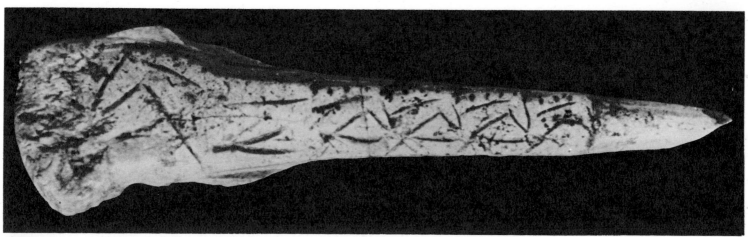

86

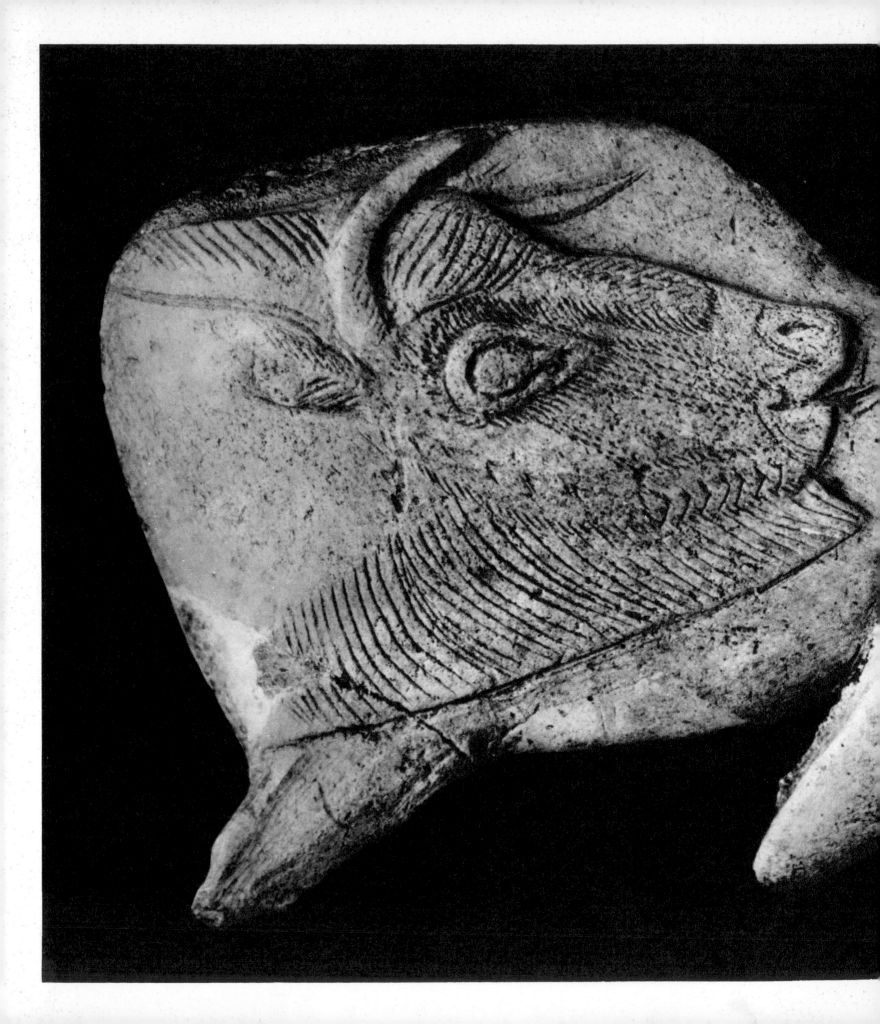

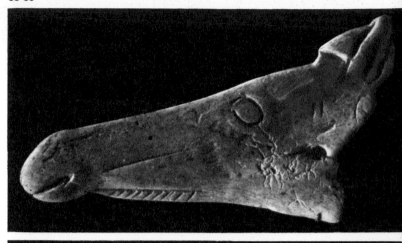

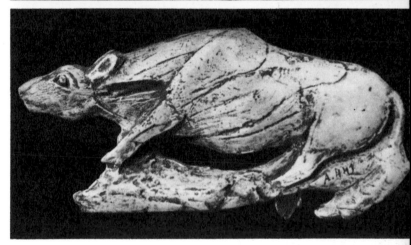

87    La Madeleine (Dordogne). Bison with its head tur-
ned back, an example of monumentality in "art mobi-
lier." Brilliant observation has been skillfully translated
into execution. (Museum of Saint-Germain-en-Laye.)

88    Isturitz (Basses-Pyrénées).    Silhouetted horse's
head. (Saint-Périer Collection.)

89    Laugerie-Basse (Dordogne). Reindeer carved in
the round.

90    La Madeleine (Dordogne). Feline (?) in ivory carved
in the round.

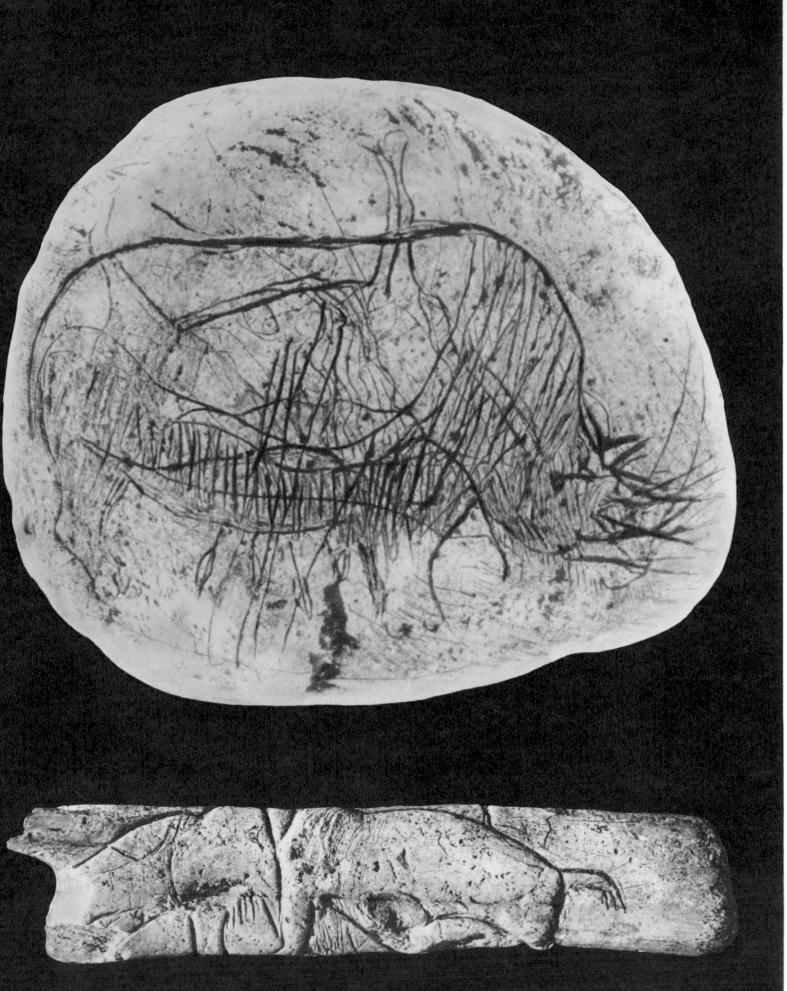

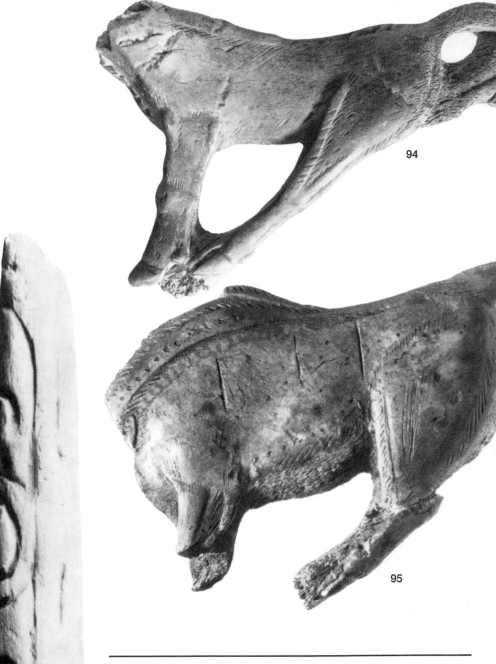

91 La Colombière (Ain). Example of a "complex" engraved on a pebble. The superposed animals are oriented in all directions on the movable object. The most prominent is an excellent rhinoceros. (Opposite page.)

92 Laugerie-Haute (Dordogne). Facing mammoths in shallow relief on a perforated staff. (Museum of Les Eyzies.) (Opposite page.)

93 Isturitz (Basses-Pyrénées). Semi-cylindrical staves with spiral ornamentation. The function and significance of these staves are unknown. (Saint-Périer Collection.)

94 Arudy (Basses-Pyrénées). The headless animal, which has been identified as an ibex, served as a hook on a throwing stick. The legs show particularly good observation.

95 Fragment of another animal depicted as on the verge of springing.

93

94

95

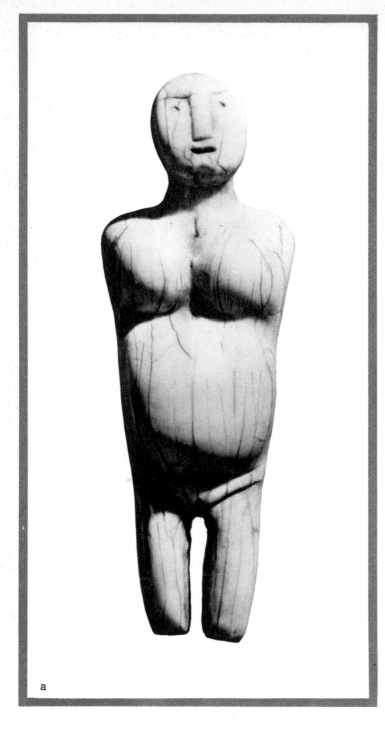

a

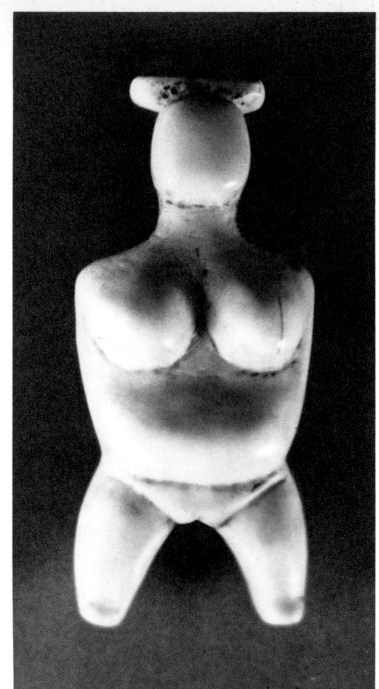

b

c

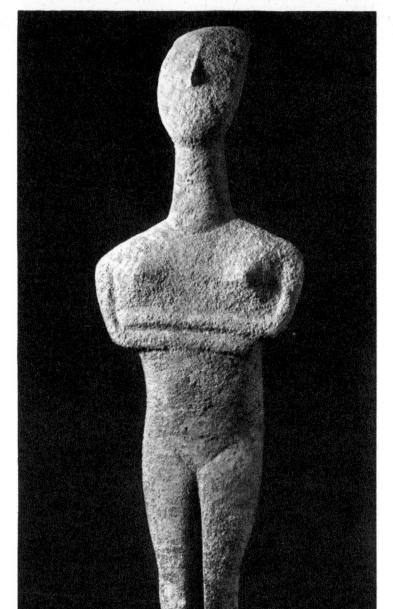

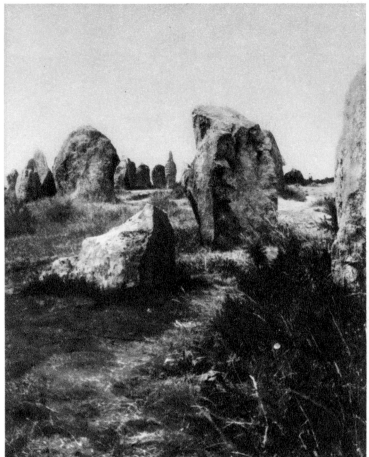

e

d

97

---

96 Modern and classic primitive carvings.

(a-b) Eskimo sculptures of the nineteenth century (?) Both are carved, from walrus tusk. The workmanship is decadent in the first sculpture, better in the second. The head in the second piece is slightly reminiscent of the prehistoric Venuses. (Kerchache Collection.)

(c) Le Mas-d'Azil (Ariège). For contrast, the head of a neighing prehistoric horse, powerfully characterized. (Museum of Saint-Germain-en-Laye.)

(d) Cycladic idol made of marble.

(e) Libya. Almost childish engravings of bovids. Note the horns passing through the heads and the crossed lines on the flanks. (Mission de Tomâs.)

97 Brittany. Another world: the Neolithic and its avenues of menhirs.

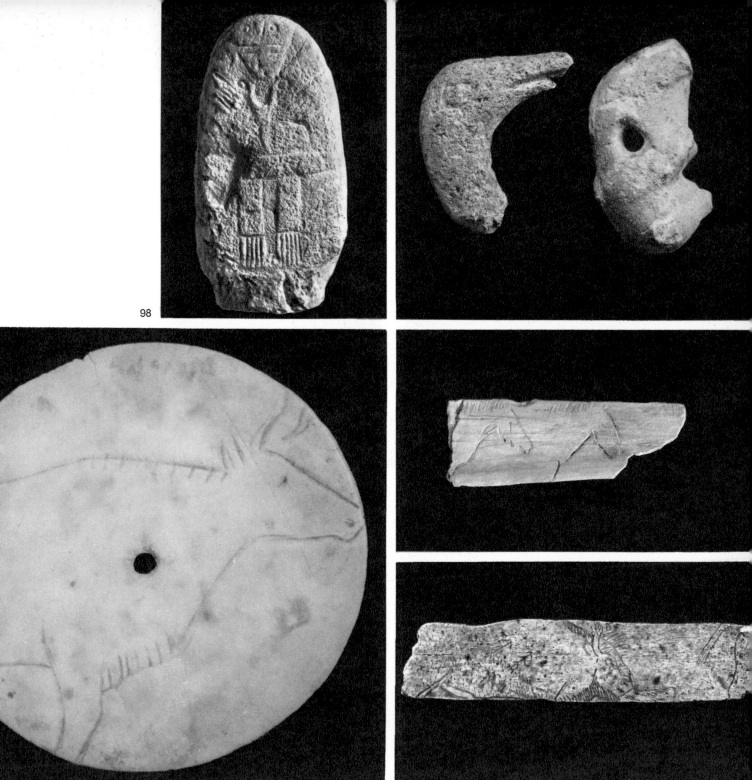

98  A menhir statue from the department of Aveyron, Neolithic period. This work shows a very rudimentary hieratism absent from Western Upper Paleolithic art.

99  Isturitz (Basses-Pyrénées). (a) Little sculpture in the round of a goose's head. (Saint-Périer Collection.) (b) Small perforated figure of a bear doubtless meant to be suspended. The head with its rather delicate muzzle shows few details, and the legs are barely indicated by depressions at the hip joints. But the figure as a whole conveys the characteristic chunkiness of the animal.

100  Laugerie-Basse (Dordogne). Bone disk engraved with the forequarters of a bovid. The central hole has suggested, without compelling reason, that such disks might have been used as buttons on garments.

that are hard to read, and the very fine panel with two bovids at Bourdeilles (Dordogne; Fig. 73).

Generally speaking, bas-relief repeats the iconography of mural painting — associations of animals or scenes with a man attacked by a bison — but it adds elements more especially suited to the lighting of shelters, as can be seen, for example, in the three partial female representations of Angle-sur-l'Anglin and the two recumbent women of La Magdeleine (Tarn; Fig. 69). In the latter two, interest is centered on the pubic triangles, defined with a precision that does not forfeit charm. Their shapes are slender, moreover — something rather rare, as we shall see, in female representations of the Paleolithic. With their heads propped on their arms, they lie in an attitude of voluptuous abandon, their exquisite contours, in an arabesque reminiscent of Matisse, defined under a subdued light between true shade and daylight.

The translation of feminine beauty does not always conform so well to our tastes, but there is no question of evaluating reliefs such as those of Laussel, for example, according to contemporary aesthetic norms. As a plastic object, the principal figuration of Laussel, the "Venus with the Horn" (Fig. 55), is a great masterpiece. The delicacy of the modeling and the harmony of the curves, still perceptible in the piece detached from its base, allow one to envision what a powerful and venerable image of "Woman" must have presented itself from on high to those who admired it in its original overhanging position. The authority of this major representation is in no way diminished by an adiposity that, like the Greek nose or the Gothic dislocation at the hips, reflects a convention. Proof is furnished by a comparison with the masculine relief in three-quarters view (Fig. 70) also found at Laussel: in spite of his slenderness, this personage does not for a moment have the distinction

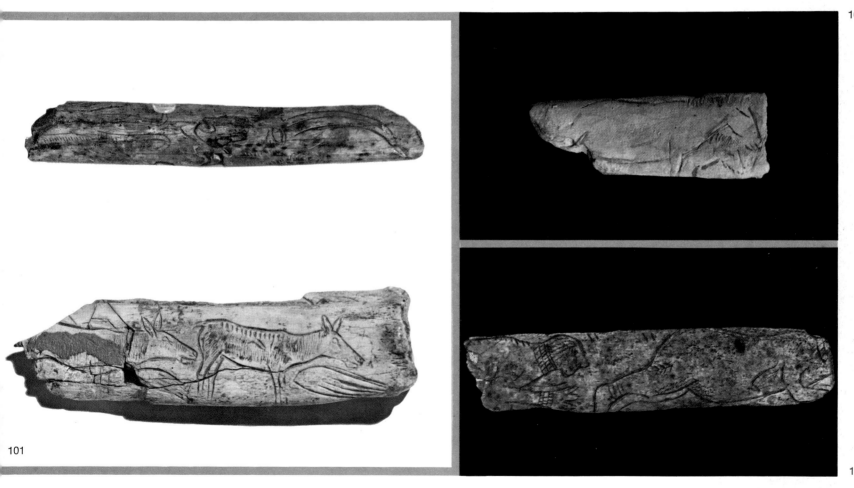

101 Fragments of bone decorated with engravings. (Opposite page and above.)

102 Le Chaffaud (Vienne). Staff engraved with hinds. Found in 1834, this is the first discovered work of prehistoric art.

103 Isturitz. Engraved fragment in a mediocre style, showing one personage following another. The meaning is enigmatic. (Saint-Périer Collection.)

of the "Woman with the Horn." The various figurations of Laussel, like a great many others, seem linked to the theme of fecundity. Two other, less complete "Venuses" (one in Berlin, and the other (Fig. 59), interesting because of her reticulated hairdo, in Bordeaux) exhibit oversized breasts. Phallic representations and a curious lozenge-shaped plaque (Fig. 57), which has been interpreted as a parturition or copulation scene, complete this ensemble of reliefs, without attaining the level of the first Venus.

The rather inappropriate name of "Venus" is also applied

104   The two styles of prehistoric decoration.
Top:   a regular geometric pattern on a spatula from
Lalinde (Dordogne);
Bottom:   a brilliant naturalistic rendering of a wolf's
head.

to the numerous little female nudes in ivory, limestone, or clay found over a considerable geographical expanse. Their distribution map, which follows a west-east axis from the Pyrenees to Russia, does not coincide with that of mural painting, which follows a north-south axis from southwestern Europe to southern Africa. Under the heading "Aurignacian Venuses" — they mostly date from the late Gravettian and the Solutrean — can be grouped works of unequal quality but of an astonishing unity of inspiration. The finest is the Venus of Lespugue (Fig. 65), whose monumentality and sheer perfection as an object are undisputed. Like it, the majority of these figurines can be inscribed in a lozenge. The head is small and often reduced to the mass of hair. The little head of Brassempouy (Fig. 78) with its reticulated hairdo is more detailed. The statuette often ends in a point, which suggests that it may have been stuck in the ground. The essential central portion, with the breasts, the belly, the sexual organs, and the buttocks, is always enlarged into a strongly modeled mass, while the arms, joined in front, are small and frail. The Czechoslovakian and Russian examples, inferior in quality to the Pyrenean, offer variants in the modeling. The type evolved toward stylization at Mezine (Fig. 67), and the pubic triangle, as well as the position of the arms, are found again later in innumerable "fertility idols" such as the Cycladic ones (Fig. 96).

105 *Silhouette of a young cervid. The exaggeratedly large eye is engraved in a circle.*

106 *Le Placard (Charente). Perforated staff with bird's or man's head carved in the round. A hollow where the eye would be suggests an empty socket rather than the living organ of sight. A deep furrow underlines the base of a short, thick, and firm beak. The whole thing looks less like a head than a skull.*
*It is possible that the pieces of "art mobilier" once called "bâtons de commandement" and now known simply as perforated staves served to straighten the points of assegais. Their form is more or less constant, with a hole pierced in a reindeer antler at a point where it forks. In the Magdalenian period the part functioning as a handle was often transformed into a phallic representation. The decoration, dominated by the horse, very rarely draws its inspiration from the bird, as it seems to do here.*

107 *Throwing stick of reindeer antler, decorated with a horse whose outlines are rendered in shallow relief while the cylindrical mass of the instrument constitutes the body. This is an extreme example of the adaptation of a work of art to a functional shape.*

108 *Le Mas-d'Azil (Ariège). Stem of a throwing stick in reindeer antler, carved with an animal that takes the shape of the object it is supposed to adorn.*

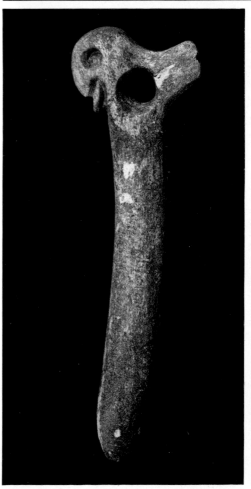

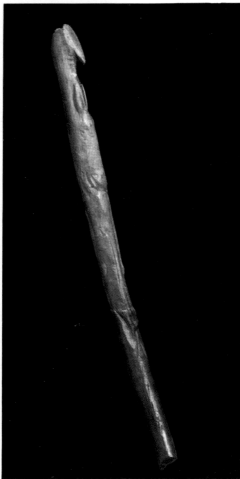

109 Picture of a fish by men who "live prehistory" in Australia. Compare with the treatment of the same subject (Fig. 113) by men belonging to early prehistory.

110 Late ivory sculpture, probably of Eskimo origin. The scene evokes a strange man-bear relationship, perhaps of the same order as the prehistoric associations of sexual organs, or the forms derived from them (see Fig. 32). (Author's collection.)

111 Laugerie-Basse (Dordogne). Engravings. Left: Frail, nervous legs of a cervid. Right: Recumbent pregnant woman. (Opposite page.)

112 Limeuil (Dordogne). Horse's head captured with a few engraved lines. Such works seem to demonstrate that a great facility, born of mastery of the craft, presided over the prehistoric creations. The secret seems to have been lost in the somewhat tediously elaborated primitive animal of Fig. 115, a clay and wax hippopotamus from Mali. (Opposite page.)

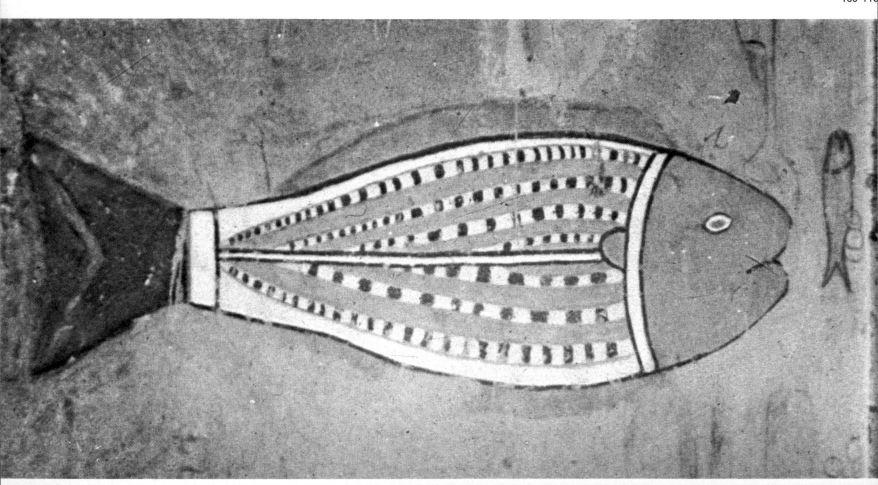

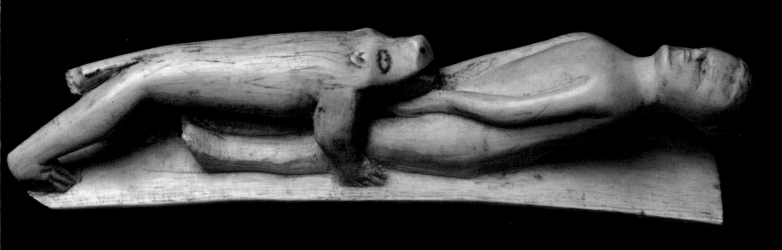

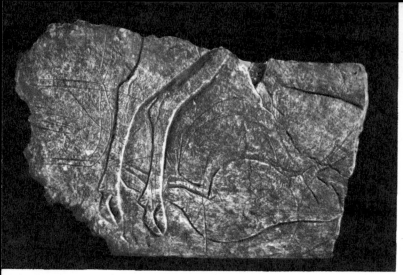

113 Niaux (Ariège). Salmon or salmonid traced on the clay ground of the cave. The contrast between the prehistoric version of a fish and the Australian one (Fig. 109) is that between lifelike representation and stylization. But the realism of the prehistoric fish is not incompatible with an indication of the body axis by one swift stroke or with the selection of but a limited number of expressive details.

114 Alaska. Asymmetric Eskimo mask of walrus ivory. The structure of the face gains power through geometrized details, but the work lacks relief.

## Art Mobilier

The distinction between sculpture and "art mobilier" is a rather delicate one to establish: in one sense the little Venuses are movable art objects and the hooks of throwing sticks adorned with flayed horses's heads, for example (Fig. 85), are sculpture.

It is, however, possible to distinguish, as Leroi-Gourhan does, objects belonging to a "religious art mobilier," which would comprise statuettes of animals and human figurines — the latter pretty well confined to the Venuses — and decorated objects. But the humblest decorations of plaquettes or of suspensible objects may have a religious character, like the plaquette of Raymonden; and even utilitarian objects — assegais — may display admirable figurations, sometimes naturalistic, but more often stylized or abstract (Fig. 104).

The very rich and varied "art mobilier" ranges from silhouetted objects, such as the delicate horses' heads from the Basses-Pyrénées area (Fig. 88), to the still enigmatic semi-cylindrical staves (Fig. 93); from bone disks to ornamented spatulas and weapons. The use of engraving, the overlappings with sculpture, and the presence of the same themes used in painting make for an art that, highly developed technically and heavily charged with meaning, can hardly be considered minor. It is not, however, possible to deal with the problems of these absorbing works within the confines of this book.

*115 Mali. Clay and wax hippopotamus.*

# CONCLUSION

Chief subject of this book, the mural art of western Europe is a singularly privileged manifestation of prehistoric art. Here — and here alone, within the compass of the arts called prehistoric — it has seemed possible to find something like the sum of the highest experiences of a society. Although it has become incommunicable, the language of the animal frescoes of the Upper Paleolithic yet suggests that already in its own time it might have been exemplary. Its authority, the fixity of its conventions, and its striking singleness of inspiration make it, in this perspective, the oldest and the most enduring of the "classical" styles. Virile and homogeneous, the mural painting seems heavily charged with a long-held religious conception of the universe.

Our rapid survey of the periods and places fertile in prehistoric art may allow us to state that the painting of the Franco-Cantabrian caves was nourished by the most original — and for us, of course, the least fathomable — mental resources among those of all Stone Age societies. It illustrates and systematizes a unique scheme of beliefs and, no doubt, explanations that did not attain fullness until the fifteenth millennium before our era and in the few adjacent millennia. For this reason we have tried to present it as prehistoric art par excellence.

In contrast to several of the present-day admirers of prehistoric art, we do not hold that its principal merit is the realization of the first painting known to have been created by our species. Acquiring fairly quickly and fairly soon a technique and command excellently adapted to its purposes, this art is far removed, in its golden age, from elementary exercises and timid fumblings. These are creations worthy of bearing favorable comparison with all the later formulations of animal art. By refraining from praising it for a mere capacity to represent bison, we have sought to guard it from the sentiment that threatens to swamp meditations on the origins of art. Within the space of the cave the masterpieces of mural art, faithful to a peculiar deliberate pictorial organization, one which is for us surprising, bring to life a select fauna with gripping intensity. The order and choice of representations, which are the concern of contemporary prehistoric science, hold the key to a definitively closed stage of human thought.

The art of the Neolithic cultures would normally have been included in an investigation concerned with prehistoric art taken in the broad sense of the term. The absence of great painting puts Neolithic art outside the scope of this book. It must be realized that the substitution of agriculture for the great hunt oriented values toward other sources: the extraordinary animal world of the cave frescoes lost its meaning with domestication. The art of the megaliths belongs to a new religion in which there arose the idea of survival in a hereafter. Sheets of little symbols cover funerary sites. Man, beginning to exploit nature, asserts himself even in death. He erects titanic alignments of upright stones and ceases decorating with precise pictures of the fauna the secularized subterranean sanctuaries of the previous religion. With the use of pottery, followed by that of metals, revolutionary ways of life spread from centers of dissemination radically different from those of the Upper Paleolithic.

Although the notion of an abrupt change after a "hiatus" has been discarded, it remains true, nonetheless, that such transformations — gradual and variously datable according to country as they might be — brought about a kind of mutation in the human condition. Another stage begins: "The Neolithic, with which the modern world opens, represents a decisive turn, a complete rupture with the past" (Lantier). We have confined ourselves to suggesting the peculiar character art assumed in the previous civilization. The mural painting, it seemed to us, represented something like the spiritual testament of that civilization: bound up with its fate, the art did not survive it.

To the degree that engraving was related to mural painting, by its graphic conventions and by its meaning, it shared the same lot. Let us recall, however, that applied to objects of "art mobilier" it evolved toward a purely schematic, then abstract, decoration. In this form, as well as in realistic representations, which are sometimes weak and often emptied of all religious content, it was to perpetuate itself, frequently as part of a small-scale sculpture, while deteriorating into the naive art of knife-handle carving and scrimshaw. But in its purely Paleolithic form — the "complex" — it attained a unique state of complications, thus becoming a very special problem that has been little studied.

Sculpture can be divided into two categories on the basis of its survival. The first, which includes animal bas-reliefs and is linked with mural art, remained without issue. The second, to which belong the so-called Aurignacian Venuses, seems to be connected with a cult that was relatively independent of the animal-centered religion (or which may have become autonomous relative to it). The date of the first appearance of these female statuettes and their area of dissemination differ from those of the classic mural painting. The vast number of "fertility idols" testifies to the success of the type.

Between the tool pure and simple (Fig. 54), already an art object by reason of its excellent form, and the marvelous images of mural art, a great and long-lived civilization pursued its course. Our sole materials for tracing it are precisely tools and works of art. Remains astray among us of a now incommunicable aspect of an ancient way of thought, the decorations of the ornamented caves are in particular still accessible by their beauty, although they speak in a language which is dead to us. Insufficient though they may be for a total reconstitution, do they not at least suggest that this first civilization, a long way removed from wretched animal beginnings and conscious of the oneness of the living world, advanced on a royal road? Man is a being of distant horizons.

# SELECTED BIBLIOGRAPHY

## 1. BASIC WORKS (WITH REFERENCES)

Breuil, H. **Four Hundred Centuries of Cave Art,** trans. from the French by M. E. Boyle. Montignac, 1952.

Graziosi, P. **Paleolithic Art,** trans. from the Italian. New York, 1960.

Laming-Emperaire, A. **La Signification de l'art rupestre franco-cantabrique.** Paris, 1962.

Leroi-Gourhan, A. **Préhistoire de l'art occidental.** Paris, 1965.

## 2. GENERAL WORKS

Bandi, H. G., and Maringer, G. **Art in the Ice Age, Spanish Levant Art, Arctic Art,** trans. from the German. London, New York, 1953.

Bandi, H. G., Breuil, H., Berger-Kirchner, L., Lhote, H., Holm, E., and Lommel, A. **The Art of the Stone Age,** trans. from the German and French. London, New York, 1961.

Giedion, S. **The Eternal Present.** London, New York, 1962.

Grand, P.-M. **La Découverte de la préhistoire.** Paris, 1960.

Leroi-Gourhan, A. **Les Religions de la préhistoire.** Paris, 1964.

Lommel, A. **Prehistoric and Primitive Man,** trans. from the German. London, New York, 1966.

Maringer, J. **The Gods of Prehistoric Man,** ed. and trans. from the German by M. Ilford. New York, 1960.

Narr, K. J. "Vorderasien, Nordafrica und Europa," in **Abriss der Vorgeschichte.** Munich, 1957.

Nougier, L.-R. **L'Art préhistorique.** Paris, 1966.

Saint-Périer, R. de. **L'Art préhistorique.** Paris, 1932.

Reinach, S. **Répertoire d'art quaternaire.** Paris, 1913.

Zervos, C. **L'Art de l'époque du renne.** Paris, 1959. (Important for **art mobilier).**

## 3. REGIONAL STUDIES

### A. FRANCO-CANTABRIAN REGION (also studied in most of the works listed above)

Bataille, G. **Prehistoric Painting: Lascaux; or, The Birth of Art,** trans. from the French. by Anstryn Wainhouse. Lausanne, 1955.

Gaussen, H. **La Grotte de Gabillou.** Bordeaux, 1965.

Graziosi, P. **Levanzo.** Florence, 1962.

Nougier, L.-R., and Robert, R. **Rouffignac,** vol. I: **Galerie Breuil et Grand Plafond.** Florence, 1959.

Windels, F. **The Lascaux Cave Paintings,** trans. from the French by C. F. C. Hawkes. London, 1949.

### B. EASTERN SPAIN

Almagro Basch, M. **Las pinturas rupestres levantinas.** Madrid, 1954.

Cabré Aguiló, J. **El arte rupestre en España.** Madrid, 1915.

Narr, K. J. **Das höhere Jägertum** (Historia Mundi Coll., vol. I). Bern, 1952.

### C. AFRICA

Almagro, H. **Prehistoria del Norte de África y del Sáhara español.** Barcelona, 1946.

Balout, L. **Préhistoire de l'Afrique du Nord.** Paris, 1955.

Battiss, W. W. **The Artists of the Rocks.** Pretoria, 1948.

Chasseloup-Laubat, F. de. **Art rupestre au Hoggar.** Paris, 1938.

Frobenius, L. **Ekade Ektab: Die Felsbilder Fezzans.** Leipzig, 1937.

Frobenius, L., and Fox, D. C. **Prehistoric Rock Pictures in Europe and Africa.** New York, 1937.

Graziosi, P. **L'arte rupestre della Libia.** Naples, 1942.

Holm, E. **Südafrikas Urkunst.** Pretoria, 1957.

Lhote, H. **Die Felsbilder der Sahara.** Würzburg, Vienna, 1957.

Vaufray, R. **L'Art rupestre nord-africain.** Paris, 1939.

Willcox, A. R. **The Rock Art of South Africa.** Johannesburg, 1963.

### D. AUSTRALIA

Basedow, H. **The Australian Aboriginals.** Adelaide, 1925.

Lommel, A. **Die Unambal, ein Stamm in Nordwest Australien.** Hamburg, 1952.

Lommel, A. and K. **Die Kunst des fünften Erdteils.** Munich, 1959.

McCarthy, F. D. **The Cave Paintings of Groote and Chasm Islands.** Melbourne, 1959.

# INDEX OF NAMES AND PLACES

See Table of Contents and List of Illustrations for other references.

*Photographic documentation by Messrs. Vertut, Roussot, Dornier, Robert and Leclant; and by the photographic departments of the Musée de l'Homme and the Musée de Saint-Germain, and the archives of the editor.*

*The Countess de Saint-Périer, Mr. Geoffroy, curator of the Musée de Saint-Germain, and Mr. Valensi, curator of the Musée d'Aquitaine, have kindly authorized the reproduction of works from their collections.*

*This book has been designed by Flavio Lucchini and has been printed and bound by Amilcare Pizzi S.p.A., Milano. Plates executed by E. Dujarric de la Rivere.*